名师绘画技法系列丛书

高冬 / 主编

田宇高水彩艺术

WATERCOLOR BY TIAN YUGAO

中国林业出版社

图书在版编目（CIP）数据

田宇高水彩艺术 / 高冬主编. －－ 北京：中国林业出版社，2011.4
（名师绘画技法系列丛书）
ISBN 978-7-5038-6352-3
Ⅰ. ①田… Ⅱ. ①高… Ⅲ. ①水彩画 – 绘画技法Ⅳ. ①J215

中国版本图书馆CIP数据核字(2011)第206200号

名师绘画技法系列丛书·田宇高水彩艺术

主　编　　高冬

策划编辑	吴卉　牛玉莲
责任编辑	吴卉
封面设计	高冬　周亮
装帧设计	周周设计局
摄　　影	彭波
出版发行	中国林业出版社
	邮编：100009　　地址：北京市西城区德内大街刘海胡同7号
	电话：83224477　E-mail：jiaocaipublic@163.com
	http://lycb.forestry.gov.cn
印　　刷	北京雅昌彩色印刷有限公司
经　　销	新华书店
版　　次	2012年1月第1版
印　　次	2012年1月第1次印刷
开　　本	889mm×1194mm　1/16
印　　张	5.5
字　　数	290 千字
定　　价	68.00元

凡本书出现缺页、倒页、脱页等质量问题，请向出版社图书营销中心调换

版权所有　侵权必究

序

清华大学高冬教授主编的当代水彩艺术《名师绘画技法系列丛书》嘱我写序。他认为我在绘画艺术和设计艺术的关系方面的一些论点很合他的意图，因此，将《吴良镛"画记"》所写的序言和跋的一些文字凝练成一篇文章拟作为本《丛书》的序。我看了一遍，那是10年前即将度80岁为出画集时所写的文章，看当时的激情，现在再要我作恐怕难以写出来，但文章可以参考，可以作"吴良镛论绘画"附录于后。因此决定专写一篇。

这些年来由于计算机的进步，为建筑图的制作提供了极大的方便，制作建筑渲染图无论技巧、表现能力，都有了意想不到的提高。一般竞赛的建筑表现图几乎看不到大型的水彩渲染图，可能也出于同样原因，学生对水彩画练习的兴趣，由于照相机和计算机性能的进步，所应具备的建筑师的速写习惯也减退了。我个人对这种现象有如下的看法：

1. 对于计算机制图的进步与普遍地推广运用，这毋庸置疑。它的建筑艺术创作，也需要多方面的艺术修养。

2. 手绘建筑画的表现技巧并不因上述情况而否定。举一个例子：清华大学建筑学院前景观系主任Laurie D.Olin（欧阳劳瑞），他是美国艺术与科学院院士，在传授他的园林建筑设计作品时最后总要放映他设计作品的水彩画表现图。我每次见到均颇为欣赏，不仅技巧好，寥寥数笔对设计内容表现得淋漓尽致，并且他所表现的对象充满阳光和所在环境的空间层次感、色彩感给人以美的享受。这种诗情画意的表达、这种艺术境界的取得取决于美术修养，不是计算机制图所能达到的。

3. 照相技术的进步大大提高摄影水平，这为建筑师提供了方便，但照相机只是工具，关键要看建筑艺术修养。从建筑师使用它我注意到一种情况，尤其在旅游团组织越来越普及的情况下，日程安排很紧去很多地方，于是照相机咔嚓咔嚓……照了很多照片回来，这不是没有用，但作为建筑师速写这一环节却每每被略去了，这是很可惜的。

摄影艺术是特殊门类，照相机照观赏对象与建筑用速写的方式记录一个对象效果是不一样的。速写是通过眼的观察、取景、选择，然后再到用手记录下速写稿，成为一幅画。即使是最潦草的一幅画，它也是一幅画作，好的话它还是一件艺术品。即使是一幅不完整的艺术品，它也是对你观察的对象一个完善的欣赏练习过程，比照相记录内容充实多了、丰富多了。一个建筑的学习者如果失去了这个训练是可惜的，而且是无法弥补的。以我个人的经历为例，我跑过不少地方，有的做了速写，有的仅做了摄影甚至连像也未照，凡是做了速写的，至今几十年后甚至半个多世纪以后仍历历在目，而一般照相不免模糊甚至遗忘了。

高冬教授主编《名师绘画技法系列丛书》是件很有意义的事情，该系列丛书选了十几位国内著名水彩画家的代表作品，每人一集，他们的艺术代表了我国目前水彩艺术的整体水准，又多是从事水彩艺术教学的教授、专家，其画作的艺术就不用我辍言了。希望通过这套《丛书》的出版，能让我们的青年和学生在水彩艺术的表现技能和艺术修养方面有所提升。

中国科学院院士
中国工程院院士
吴良镛
2010年9月3日

Preface

I have been requested to write a preface for *The Serial Books of Painting Skills by Famous Masters* for contemporary watercolor art compiled by Professor Gao Dong of Tsinghua University. He thinks that a few ideas of mine concerning relations between painting art and designing art are in line with his own intentions. So he mixed some words of the preface and postscript in the Remarks on *Wu Liangyong's Picture Album* and rewrote an article to be used as the preface for the book. When I read it, I found that those words were written ten years ago for my picture book that would be published prior to my 80th birthday. I am afraid that it is difficult for me to write such an essay based on the passion at that time. But the essay could be used as a reference and attached to the book as *Comments on Paintings by Wu Liangyong*. Therefore, I have decided to write a new one.

Thanks to progress made by computer technology in these years, computer can provide great convenience for architecture drawings. Techniques and expressivity of architectural rendering have been improved in an unexpected way. It is seldom to see large-sized color renderings in general architectural competitions. Students lose their interest to practice watercolor and their sketching habit to become an architect, due to high performance of camera and computer. Personally, I have my own opinions as follows.

1. It makes no question of the advancement in computerized drawing and its wide application. Creativity of architectural art needs training in many respects.

2. The expressive techniques of architectural paintings by hand will not be denied owing to the above mentioned. For example, as an academician of American Academy of Arts and Sciences, Mr. Laurie D. Olin, a former dean of landscape department of architecture college of Tsinghua University, would always show his watercolor expressions for his designs when he taught his garden architecture. I would be appreciated each time when I saw these works which were not only fine with just a few lines for most expressive, but also offered enjoyment of beauty with a sense of space and color for the object. The poetic expressions depend on art accomplishments, but not from computer drawings.

3. The advancement of photography has greatly improved photographic level, which provides convenience for architects. However, camera is only a kind of tool. The key point relies on art accomplishment of architecture. I

have noticed a fact that architects use cameras. When tourism gets more and more popular and traveling destinations become so many, cameras turn out to be more efficient to produce a lot of pictures. This is not useful, yet it is pitiful that sketches for architects are neglected.

Photography belongs to a special class of art. It is different from recording an object with a sketch for architecture to viewing an object through a camera. A sketch is a painting resulted from observation and selection to record by hand. Even if it is made in a hurry, the sketch is a drawing. If it is good, sometimes, the sketch will become a piece of art works. A sketch is a perfect process of practice for your observing an object, which contains full and rich information compared with record by camera. It is to be regretted for an architecture learner to lose this opportunity of training that can not be made up. Take my own experience for an example, I have been to many places where I had sketches, took photos or even no pictures. Those things in sketches are still vivid in my mind decades of years later or even half century passed. But I cannot remember clearly or have simply forgotten those with photos.

It is significant for Professor Gao Dong to edit *The Serial Books of Painting Skills by Famous Masters*. Representative works of dozens of watercolor artists famous at home are selected in the serial books, one book for each painter, which represent the watercolor artistic level of China at present on the whole. Most of these painters are professors or experts engaged in teaching of watercolor art. It is unnecessary for me to comment on their works. I hope that when the serial books are published, expressive techniques and artistic appreciation of watercolor art for the youth and students will be enhanced.

Wu Liangyong
Academician of Chinese Academy of Sciences
Academician of Chinese Academy of Engineering
September 3, 2010

吴良镛论绘画

一般来说，建筑师把习画作为建筑学习的一部分，即训练徒手画的表现技巧，以得心应手地表现建筑的构图、质地、光影，以及自然环境等。这方面奥妙无穷。只要看一看梁思成、杨廷宝、童寯等先生的建筑画，以及西方建筑师的草图（例如宾夕法尼亚大学建筑档案馆所藏的路易·康等人的手稿，1987年在巴黎蓬皮杜中心举行的柯布西耶百年展陈列的他早年意大利之行的速写与水彩），你就不能不为其飞动的线条、斑斓的色彩背后闪现的灵感与创作思想所感动。现代的制图工具与计算机技术发展很快，甚至达到了准确如实物摄影的程度。但对比前辈大师，现在建筑学人中徒手表达能力有削弱的趋势，对此，我感到困惑。就我个人来说，并不满足于建筑表现技术的学习，而是希望从习画中加强对艺术和文化的追求。我发现有些以建筑为题材的绘画要比一般建筑画更富意境。例如在西方一些大博物馆中几乎都可以看到描写威尼斯圣马可广场以及一些名都圣地的画，它不仅是建筑的表达，更是风情的记录。自文艺复兴后透视术的发明，表达建筑构想的画多了起来，有所谓"建筑幻想图"（architectural fantasias），例如，18世纪Piranesi早期铜版画，德国古典艺术大师辛克尔（Schinker，身兼建筑家、画家、雕塑家、工艺美术家、建筑教育家）把建筑、风景的描写与遐想以游戏之笔作舞台布景的构图，独辟蹊径；在中国，如《清明上河图》《千里江山图》《姑苏繁华图》等，一般我们也不把它作为建筑画来欣赏，而是看作当时城市文化和大地风情的写照与记录。由于对文人画的过分推崇，中国传统上有点看不上以表现建筑为主的"界画"，其实袁江、袁耀、仇英、蓝瑛等的山水建筑画就是"中国式的建筑幻想画"，其环境意境、空间层次、虚实对比、于山水林木的结合等，颇能给习建筑者以启发。

建筑意与画意，意境与艺境的统一。建筑是科学，也是艺术，包括美的结构造型与环境的创造，梁思成先生称之为体形环境，因为自然界万物是有体有形的交响乐，对人居环境美的欣赏、意境的追求、场所（place，建筑术语）的创造，可作为人居环境艺术的核心方面。无论建筑设计还是城市规划与园林经营，都需要"立意"，讲求意境之酝酿与创造，讲求"艺境"之高低与文野。前人云"境生象外"，要追求"象外之象""景外之景"，而"象外之象""景外之景"不是凭空而来的，需通过观察体验，发掘蕴藏在大自然、大社会的文学情调、诗情画意加以塑造的。在这里有形之景与无形之境是统一的，建筑、绘画、雕刻、书法以至文学、工艺美术的追求是统一的。明乎此，

美术、雕刻、建筑、园林，大至城市规划、区域文化，美学的思考与追求和而不同，但它们是统一的。

人工建筑与自然建筑之交融。我对建筑专业有了较多的学习和实践后，更意识到建筑师的建筑观不能局限于单幢房屋，而应以更为开阔、更为宏观的视野，广义地理解建筑。建筑师面对的是人和自然，因此建筑的世界当以"人工建筑"（architecture of man，如房屋、街道、村镇等，无一不是建筑）为本，与"自然之建筑"（architecture of nature，树木、山川等一切自然环境的世界）为依归，融为一体。在此，"建筑"二字已非一般房子的含义，应是广义的建筑，这两者是如此的密不可分，可通称为"人居环境"。建筑师的终生追求，不仅要深入人居环境科学，还需对人居环境艺术，对蕴藏其内的艺术的规律，做力所能及的较为全面的涉猎与追求，予以整体的创造。因此，绘画以及全面的艺术修养的提高，就至为重要。

20世纪以来绘画、雕塑与建筑互为影响，创新无限，例如包豪斯的出现，不只是新建筑学派的兴起，建筑教育的变革，而且是现代文化思想、绘画、雕刻、工艺美术、视觉艺术一系列新追求的综合现象之一。荷兰海牙博物馆收藏了一套蒙德里安（P. Mondrian）的画，可以看出它是如何从自然风景逐步演化为几何图案，后来又如何影响建筑的构图的。同样，建筑的艺术亦每每影响绘画与雕塑的造型。今天科学与艺术的结合前途更加广阔无垠。

人类社会追求的就是要让全社会有良好的与自然相和谐的人居环境，让人们诗意般、画意般地栖居在大地上。这是一个建筑师的情怀。我们这个星球的内容、色彩、情趣都要比我们常眼所见的丰富千万倍，设计者各自如能放开眼界观察自然，通过绘画及其他艺术，多一些文化修养，以谨慎的态度对待专业，就能少一些粗劣与平庸，我们的生存环境可能要宜人得多。例如中国的园林艺术就是从大自然中移天缩地妙造而成的，从南宋的应试画题起，用文学的语言，激发绘画意境的创造。城市中的"十景""八景"（如西湖十景、燕京八景等），堪称世界最早的主题公园，更是大自然与人间情怀的交融，经过时间的推进，以及增饰、改造、洗练而成的风景名胜留传下来，至今仍有借鉴之处。但学者不能停留于此，依样葫芦，舍本逐末，更应读万卷书，行万里路，探源求本，即将枕外山川化为胸中丘壑，创造性的纳入规划设计中。我们希望人们珍惜、保护、创造自己的艺术环境，无知、刚愎自用只会毁坏这个环境。

Comments on Paintings by Wu Liangyong

Generally speaking, architects will regard drawing practice as a part of learning architecture, namely, techniques through freehand sketch to express structure, texture, light and natural environment of building, which is extremely profound and full of interest. Just have a look at architectural drawings of Mrs. Liang Sicheng, Yang Tingbao and Tong Jun, or rough sketches of western architects (for instance, holograph manuscripts of Louise Kang, et al collected by the architecture archives of Pennsylvania University; sketches and watercolor of Le Corbusier in the centenarian exhibition at the Pompidou Center in Paris in 1987 displaying his early year travel in Italy), you will be touched by the flash aspiration and creative thinking behind moving lines and bright colors. Modern drawing tools and computer technology have made such great progress that they reach as accurate as macrophotography. Comparing with masters in the past, however, nowadays there is a tendency for architects to be weak in freehand sketch, about which I feel confused. Personally, I am not satisfied with learning of architectural expressive techniques. I hope I can strengthen my pursuit in art and culture from drawing practice. I have found that some architect-themed paintings are richly conceived and better than general building pictures. For instance, paintings depicting St Mark's Square at Venice or other famous places can be found in big museums of western countries. These pictures are not only expressions of architecture, but also records of charm. Since the invention of perspective after the Renaissance, drawings such as architectural fantasias to express architectural concept became more, for example, early copperplate etching of Piranesi in the 18th century, structure of stage setting of German classical artist Schinker (an architect, painter, sculptor, technologist and architectural educator) by combining description and imagination of architecture and landscape with the technique of game playing. In China, paintings like Riverside Scene at Qingming Festival, Landscape of Vast Expanse and Prosperous Suzhou are generally not regarded as architecture, but as the then records of urban culture and local customs. Because of high praise for paintings of literati, building picture mainly represented by architectural expression is not thought much by the Chinese tradition. As a matter of fact, paintings of landscape and building by Yuan Jiang, Yuan Yao, Qiu Ying and Lan Ying are architectural fantasias in Chinese style, whose environmental conception, space gradation, comparison and integration of mountain, river and forests can considerably enlighten architecture learners.

Concepts between architecture and painting are unified, so is artistic conception and artistic environment. Architecture is either a science or an art including beauty of structural modeling and environmental creation. Mr. Liang Sicheng called it bodily environment, because creatures in nature are like physical symphony, which can be regarded as the core of habitat environment art for appreciation of beauty, pursuit of conception, and creation of place. Architectural design, urban planning or garden operation needs artistic conception for deliberation and creation, as well as artistic environment for taste and difference. An old saying goes like this "concept obtained from things". Pursuit in "appearance beyond things" and "sight from scenes" does not derive from imagination, but is portrayed by literature from the nature and society through observation and experience. Tangible scenes and intangible conceptions are unified,

so is the pursuit of architect, painting, sculpture, calligraphy, and even literature, arts and crafts. It is understood that aesthetic perception and pursuit of fine arts, sculpture, architect, gardening, as well urban planning and regional culture are various but harmonious, and they are unified.

Architecture of man and architecture of nature is mixed. When knowing and practicing architecture more, I have become well aware that the outlook of an architect cannot be limited to a single building. He should understand architecture in a generalized way with a broader and macroscopic view. What architect faces is man and nature. Therefore, the world of architecture should center on architecture of man (houses, streets, villages and towns are architecture), based on and mixed with architecture of nature (including natural world of trees, hills and rivers). Here architecture should be the generalized buildings, not the meaning of common houses, for these two are inseparable and called habitat environment. A lifelong pursuit for an architect is not only devoted to the science of habitat environment, but also reads and seeks widely art of habitat environment and artistic law for creation as a whole. Thus it is important to improve drawing and all-round artistic accomplishment.

Since the 20th century, painting, sculpture and architect have influenced each other with creations. For example, appearance of the Bauhaus was not the emergence of a new architectural school and the reform of architectural education, but one of the serial pursuing comprehensive phenomena of modern cultural thinking, painting, sculpture, arts and crafts, and visual arts. The Hague Museum of Holland collects a series of paintings of P. Moundrian, from which natural landscapes evolve step by step into geometric patterns that have impacts on architectural compositions. The same is true for architectural arts to influence configuration of painting and sculpture. Today prospects of the combination of science with art will be brighter.

What is pursued by mankind and society is just to provide communities with nice habitat environment in harmony with nature so that people can live on poetic and picturesque land. This is the ideal of an architect. The content, color and taste on this small planet are richer thousands of times than what we see with our own eyes. If a designer can free himself, by means of painting and other kinds of arts, to observe the nature with a prudent attitude to his profession and is well cultured, then we will have fewer things in poor quality and commonplace. In this way, our survival environment may be preferable. Formed from the nature, for example, the Chinese gardening art stimulates creation of painting concept and environment by literary language from painting topics for examination since the dynasty of the South Song. Ten scenic spots or eight scenic areas (such as 10 sights around West Lake and 8 scenes in Beijing) can be considered as the earliest theme parks in the world and the blending of nature and world. As time goes, scenic areas remain because of embellishment, upgrading and improvement, whose experience can still be of use for others nowadays. However, scholars cannot follow existing examples and stop here. They have to read more and practice more for further exploration so as to learn from nature and carry out creative work for their designs. We hope that people will treasure, protect and create their own artistic environment. Innocence and obstinacy can do nothing but destroy this environment.

主编的话

　　田宇高先生的水彩艺术风格最主要的特征是纯真、质朴、感人。这样的艺术标准其实应该是所有的艺术家追求的目标，但是青年学生常常被艺术本质之外的东西所吸引，被所受教育的局部目标所诱惑，偏离艺术的根本目的，去追求华丽的技巧和炫目的形式语言，从而忽略了对本质的思索和追求。如果把艺术、风格、形式、流派放到艺术史的尺度上去考察，就会发现有些东西是永恒的，而某些东西是一时吸引了人的眼球，艺术评价无非有两个基本尺度：一是对历史上的艺术风格、技巧的了解和继承程度，另一个就是艺术家自我个性、情感的表达，以及表达方式的创新。学院派更看重前者，而美术史留下来的往往是后者，由于历史的原因，田先生这一代艺术家在教育机会上是不幸的，但在艺术的自由和个性的发挥方面却是幸运的。这样特定的机遇反而成就了他们艺术的个性面貌，形成了自己的艺术风格。

　　艺术教育的科学化、体系化是教育者追求的目标，对教育来说，系统的完善，标准的清晰、明确是教育成熟的标志，但是，这种教育的标准化往往是艺术的悲哀，艺术是属于创造的，而创造是反体系化、反程式化的，艺术是人对自然的本能感受，是人的纯真本质的自然流露，而自然天性的本质是和外部教育的参与程度成反比的，从这个角度来说，田宇高先生这一辈艺术家又是幸运的，他们没有被系统教育的尺子度量过，也就没有形式的约束，可以完全依照自我的天性发展自我。他们对艺术的热爱来自天性，对艺术的信仰就是按照自己对艺术的理解无拘无束的表达自己。这样的艺术风格必然是对自然本质纯真的真情描绘，其表达手法也一定是质朴天成的个性抒发。

　　艺术家的天性都是热爱自然、热爱生活的，田宇高先生的绘画题材多是以风景为主。画家陶醉于它关注的自然变化：春、夏、秋、冬，风、晴、雨、雾无不收入画幅，成为绘画表现的题材，而研究用色彩表达自然的万千变化，是水彩画的擅长，在微妙的灰色调中如何使色彩饱满、丰富，表现内心的丰富情感，经过多年的探索，反复尝试终于可以运用水彩特有的表现力，运用色彩和造型的手法，表达出对自然的感受。最主要的是，这样的感受不是抄袭别人的套路化的表现方法，而是自己心灵对自然的呼应，是中国文化熏陶下的高尚灵魂艺术化的自身的显现。研究田宇高先生的绘画，最重要的是他艺术的直接性，书写式的挥洒和用笔用色，性情所到之处的直接表达。最可宝贵的艺术趣味就是高尚的内在情感，质朴的造型追求，和丰富多变、不拘一格的表现技法。艺术形式合法度但不程式化，造型纯朴而内敛，用笔流畅但不油滑，笔触之间是心灵的呼吸，没有一丝苍白的装饰和做作的摆布。

　　率真的情感和执着的用心总是能打动人的心灵的，这样的艺术一定是感动人的艺术。这样的艺术是大艺术是真艺术！

于清华大学
2011年10月28日

Words from Chief Editor

The major characteristics of Mr. Tian Yugao's watercolor are natural, simple and touching. These are artistic criteria all artists aspire to reach. Nevertheless, young arts students are usually attracted by non-artistic elements and partial target, and as a result, they stray off basic principles of art seeking ornate expressions and dazzling forms, without much pondering and pursuing the arts in essence. If we mull over art, style, form and school from the perspective of art history, we will find that something is eternal, but something else only attracts eye balls temporarily. There are two basic standards for art evaluation: one is reflection of understanding and inheriting artistic styles and skills in their history, and the other is expression of artist individuality and emotions, as well as innovative ways. The former is emphasized by academic group and the latter tends to last forever in art history. Unfortunately, Mr. Tian and the artists of his generation had little access to arts education, whereas they fortunately enjoyed their artistic freedom and individuality. Their special experience actually facilitated their individualism and their own styles.

The scientific and systematic art education is the goal for educators in this field. A mature education is indicated by its complete system and clear-cut criterion. But the educational standardization is usually regrettable for art, because art is originality that is never systematized and programmed. It is an instinct to nature from human beings and a natural revelation of their pure and true feelings. It is in inverse proportion from inherent nature to product of external education. Judging from this point, not having received a systematic education, for artists like Mr. Tian, turned out to be a blessing in disguise, for they could develop their own style from their own nature without any formal constraint. Their love for art comes from instinct and gives the rein to expression of their understanding and faith in art. This art style represents a depiction of nature with true feelings and a simple and natural expression of individualism.

By nature, artists love nature and life. Mr. Tian Yugao focuses his subject mainly on landscape. He has been carried away by changes in nature such as spring, summer, autumn, winter, wind, sun, rain and mist. Good at watercolor to express numerous natural changes, Mr. Tian uses rich colors in delicate gray tone to express intense and profound emotions. After many years of exploration, eventually he succeeded in drawing on all his experience from nature with the special power of watercolor expression in color and shape. The most important is that he never follows up conventional ways, but responds to nature from his own soul, representing an artistic self-reflection of high mind nurtured by Chinese culture. The point of studying Mr. Tian's works is in his artistic directness, writing-styled paintings, skillful use of brush and color, and straightforward display of his unaffected temperament. It is the most treasured artistic taste for his intrinsic nobleness, plain structure, and varied expressions. The artistic form of Mr. Tian is appropriate, but not stylized; the formation is simple, but not flattering; the brush use is flowing, but not slick, all from heart and soul, with no trace of pallid ornament and ostentation.

This artistic style depicts nature and genuine feelings through its means that surely expresses unaffected individuality.

Gao Dong
in Tsinghua University
October 28, 2011

人如其画
—— 印象中的田宇高老师

一提到田宇高老师怎么也绕不开我初学水彩画的往事。

30年前，我大学毕业后留在大学研究菌物，当时国内研究菌物条件很落后，一没有参考资料，二没有照相机，使我茫然，一时间陷入研究菌物的困境，比如菌物采集后如何保存的问题，因为浸泡和烘干都会使菌物变形变色。后来从生物学老教授那里得知采用水彩画记录菌物的原色与外形也是菌物保形保色的好方法之一。

80年代初我在省级综合性画展上见到了田老的水彩画，其作品被放在画展全部作品的最后，虽然只是敬陪末座的小品，但他的水彩艺术却达到了很高的境界，技法相当纯熟。3个月后，我带了几幅水彩画拜访了田老，在他的鼓励和支持下我开始学习水彩画。从此以后，他经常带我去民族地区写生并给我提供差旅费，给我作示范，给我讲水彩画点点滴滴的感受。田老从水彩画的技法到绘画意境，甚至诗意与绘画的关系，都认真讲述。在田老循序渐进的引导下，我对水彩画产生了浓厚的兴趣，让我悟出其理，得知其法，使我懂得水彩画其独特的表现形式和视觉效果要求画家有更加高超的技巧才能驾驭。技法仅是表达艺术语言的手段，是反映画家对自然的感受、情感和造型的能力，意境和内涵才是赋予作品的最高境界。这一切，为我以后的水彩画研究奠定了基础。

田老一生酷爱水彩艺术，早年在北平加入了著名水彩画家衡平先生画室学习素描和水彩画。1941年结识从英国留学回来的著名水彩画家关广志，经常观摩学习关先生的作品，并受到指导和鼓励。田老的艺术思想和水彩画技法受到关先生影响很深，为他一生从事水彩画创作打下了坚实的基础。后来又结识李剑晨、张充仁、王麦秆、孟慕颐、马白水、崔家声、吴承露、赵春翔等画家，这一时期在北平、西安、上海等地举办多次个人画展及联展；1949年水彩画《工农之家》参加首届全国美展，同年加入上海美术工作者协会。1949年10月他与王麦秆、孟慕颐一起参加二野五兵团南下入贵州，后被分配到贵州省文联、贵州画报社任创作组组长，先后执教于贵州大学和贵州师范大学（原贵阳师范学院）艺术系。田老来到贵州后，这里的风土人情在田老笔下熠熠生辉，水彩画创作不断有佳作，如《春到人间》入选1954年全国水彩速写；《林区厢道》入选1958年全国美展；《侗寨的早晨》入选1960年全国美展；《伐木》入选1964年全国美展等。1967年，由于"文化大革命"严重干扰，田老的水彩画创作被迫停止。"文化大革命"结束后，水彩画创作得以复苏，田老倾注自己的感情，画出美的感受，创作了一批优秀的水彩画作品。

贵州气候湿润，最适宜画水彩画。几十年来，田老与贵州结下了不解之缘，贵州风土人情多样性让他难以忘怀。多年来，他沉醉于布依族的石板房和侗族、苗族的吊脚楼。他后来的大量的重要水彩画题材作品大多来自布依族的石板房，侗族和苗族的吊脚楼、风雨桥。笔下的石片、高山、流水、农舍、黄牛、烟云给我们留下深深的印象，如入选全国和亚洲水彩画大展的《苗家》《侗寨瑞雪》《雪霁》《憩》《清江晨雾》《晌午》《磨坊》和《侗乡银妆》等等。田老重视水彩画写生，他的水彩画中既有写生的生动，又有创作的内涵，达到了源于生活而高于生活的境界。他注重自然光色的表现和写生色彩的研究，画了近数千幅的水彩画写生，如《榕江街口》《贵阳博爱路》《晚归》

《石板房》《秋色》《桥上市场》和《雾》等都是写生的精品。我特别喜欢观看田老现场写生作画，看他水彩现场写生真是一种享受。他的画以干湿画法结合见多，讲究用色的干湿浓淡，特别是他用"水"颇见功力，水色交融，对画面力求概括，明快和湿润。田老作起画来严肃认真，对每一幅作品，无论是小幅或是大幅，从不草率从事，起稿前，他反复选择写生的角度，认真观察，总是把所画对象的主体和局部关系交待得很清晰，几乎每一幅都要花费很长的时间用于起稿上，对于复杂结构的建筑要用半天时间完成一幅铅笔稿。1982年秋，田老带我去贵州黔东南侗寨写生，仅那一次他就画了近百幅水彩画写生。其中我印象最深的是榕江增冲一幅《侗寨鼓楼》。那完整的鼓楼和周围吊脚楼的及意境的画面，仅几个小时，侗寨的鼓楼、吊脚楼的虚实与秋色的交错艺术效果表现出来，画出了秋气高洁的迷人色调，现在想起来还是那么记忆犹新：田老第一天将这幅《侗寨鼓楼》构思起稿，首先认真描绘建筑的结构及其它们之间的关系，起稿线条也是运用自如，有轻重、虚实、浓淡之别。第二天在同一时间开始上水彩，作画时，为了保持画面的色彩倾向，他很快捕捉到画面大的色彩基调，他用大笔沾着饱和的色彩趁湿一挥而就画天空，他对水分和时间把握得很好，在湿润的底色上画远景，画起来很畅快，待半干半湿的时候画侗寨鼓楼，接着画鼓楼周边的房屋和前面池塘等；近景用大笔沾着饱和的色彩趁湿一气呵成，水在画面上流动，水和色相混和后产生的画面透明空灵、微妙含蓄。他追求水彩透明、畅快，讲究和强调色彩一遍到位，尽量减少颜色的叠加和重复。田老特别喜爱画贵州布依寨的石板房，对石板房水彩画风景写生研究独树一帜，甚至成了田老水彩画的标志性的景观，他画的石板房其故不作肌理而获自然韵味在国内水彩画领域为少有。在此基础上，创作了《布依人家》《石寨秋色》《秋实》《石寨阳光》和《布依小院》等一系列优秀作品。

画雪景是他又一特长。田老自幼生长在北方，对北国的白雪有天然的情愫，他的雪景水彩画创作来源于在北方深刻体验，早在20世纪40年代，田老就喜欢画雪景水彩画。在北平、西安等地，每年冬天下雪都得画上几十幅雪景。虽然贵州下雪少，但一遇下雪，他总是那么激动、兴奋。他在冰天雪地里他不知度过多少个寒冬，有了对雪景水彩画的感悟，找到了表现雪景的艺术语言。他在继承传统"留白之法"的基础上，使用了撒盐画法，更加增强雪景的特殊肌理效果。田老画雪景得心应手、炉火纯青，所以他用水彩表现雪景画得快，也容易出效果。他的雪景水彩画给人一种身临其境的感觉，生气勃勃、活泼可人。多少年来，他的雪景水彩画作品被收藏和入选全国性水彩画大展不计其数，如《雪林》《苗寨瑞雪》《岁末》《银寨》《石头寨的冬天》和《黔灵雪径》等等。

田老的艺术积淀和学术地位日渐丰厚，其作品融合了他全部的生命、情感，形成了他独特的水彩绘画语言。他在水彩艺术上的贡献也越来越被艺术界所承认，他多次参加国内外水彩大展，出版刊行并被国家收藏，获高度评价。中国美术家协会水彩艺术委员会主任黄铁山教授感慨："先生的画品人品，确是我辈楷模。先生的水彩画，扎根于生活，是作者真诚的感受，朴实、自然、耐人寻味；先生的水彩画最鲜明地体现了水彩画的特色，透明、轻快，色彩很

美，画得洒脱自如，技法娴熟，对我们是非常有学习借鉴意义的。"著名水彩画家学张举毅教授来信提到"先生一生勤耕水彩艺术，实为我辈楷模。先生的画生活气息浓，这就使观者有一种感情上的呼应，这是很难的，再则先生特别考究水彩本身的语言艺术，始终保持着一种清丽爽目的视觉效果，这是目前很多以做工见长的人是难能体会的，先生以耄耋之年仍能保持洒脱轻松的水色情韵诚然不易。"著名水彩画家白统绪教授认为田老的"作品都是真情实感的自然流露，朴实大方、气质高雅、画得率真、随意、清新明快、赏心悦目、用笔苍劲老辣、气丰韵足，充分发扬了水彩画的特长，很多佳作都是写生得来的，往往比室内闭门造车来得更生动更有生气，既有英国传统水彩画的修养，又有浓厚的生活气息。"著名水彩画家崔豫章教授看了田老的作品感慨万分"他的足迹遍及全国各地名山大川，描写了很多美丽风光，山村野径、江河秋林、冬雪晨雾、民族风情、树皮屋、石板房等等不少杰作都给我们宁静优美宜人的享受，他的勤奋求索钻研精神结出了累累硕果。"国内著名水彩画家如李咏森、张英洪、关维兴、袁振藻、王双成、杜高杰、张克让、潘长臻、郑起妙、漆德琰、陈少平、傅启中、林日雄、柳新生、朱辉、高冬、白狄、宋惠民等教授对田老的水彩画也给予了高度的评价。田老越到晚年他越觉得绘画技术重要，观念更新和作品的内涵更重要，他的水彩画一是求美感，二是求意境，有了这二者他才动笔画，画一段水彩画后，他总是要停下思考一段时间或读一读别人的绘画作品，想方设法突破自己，并力求在各种绘图艺术表达中寻找新的艺术语言。

画如其人，人如其画。田老默默的耕耘，以毕生的精力探索水彩画艺术。他的艺术充满形式美，为老百姓喜闻乐见；他的水彩画淋漓酣畅，挥洒自如，颇有中国写意画之风韵；他的作画风格简约质朴，水分淋漓又不失于轻浮，在水色之中见神韵。原中央工艺美术学院院长张仃和著名西方美术史专家、著名美术评论家吴甲丰看了田老的作品，十分感动，张仃先生说："好！好！这个人的功力很深、很踏实、很纯熟、难得难得！"吴甲丰先生说："他的画很有生活，很有底子，画得这样好不该埋没。"两位德高望重的老先生对一个同行的如此赞许是很少见的。张仃先生主动题字"气象浑穆、厚积薄发"赞田老作品。同仁仰慕田老的水彩画真情实感、朴实无华、清新明快、意境深邃，富有浓厚的生活气息、酣畅精微的表现技巧和画意深远的艺术造诣，更敬重他的人品。田老为人谦虚、敦厚、真诚、和蔼、可亲，是一位值得尊敬的艺术家，堪为后辈的楷模。

田老88高龄，但还是那样勤奋，仍有如此鲜活的创造力，亦如他画中的黄牛精神。我常去看望田老，每次到他家总能见到田老的新作品，每次见面，除了谈水彩艺术几乎没有其他事可聊，画展、出书、水彩画销售行情等等他一概不感兴趣，他一不为名二不为利，心中只有水彩艺术事业。所以，每次见面对我都是一种鞭策、一种激励。

我的人生最大的幸福就是从事水彩艺术的研究。田老的高尚品格一直影响着我，今天我在水彩画方面取得的成果与田老是分不开的。借此，我表示诚挚的谢意，并祝田老在耄耋之年创作出更多的杰作。

国务院特殊津贴专家

二级教授

2011年10月18日

The Man, The Painting
—Impression of Mr. Tian Yugao

When talking about Mr. Tian Yugao, I cannot help thinking of my watercolor learning. Thirty years ago, I was making researches on mushroom at a university where I studied. Conditions of mushroom research were backward at that time, for there were no reference materials, nor camera. I was confused in a dilemma. I did not know how to preserve collected mushroom, because soaking or drying would make mushroom change its shape and color. Later on, I learned from old professors of biology that watercolor painting was one of the good methods to record original color and shape of a mushroom sample.

At the early 1980s, I viewed Mr. Tian's watercolor in a comprehensive provincial painting exhibition where his paintings were displayed at the rear of the exhibits. His watercolor art reached a very high level, though his paintings were shown as accompanying pieces. Three months later, I visited Mr. Tian with a few my watercolor paintings. With his support and encouragement, I began to study watercolor painting. Since then, Mr. Tian frequently invited me to go to ethnic communities to paint or sketch from nature, providing me with traveling expanses, giving me demonstrations and telling me about his painting experience. Mr. Tian honestly explained watercolor from skills to concepts, even relations between poem and painting. Guided by him, I developed a strong interest in watercolor painting. Gradually, I realized the truth, learned the techniques, and knew the requirements for special expressions and visual effects. Techniques were means just to convey artistic vocabulary to reflect a painter's feeling, passion and modeling to nature. However, concept and connotation were the highest for one's works. All this laid a foundation for my study on watercolor.

Mr. Tian loves watercolor art all his life. In his early period of life, Mr. Tian began to learn sketch and watercolor painting in the studio of a famous watercolor painter Mr. Heng Ping. In 1941, he made acquaintance with Mr. Guan Guangzhi, a famous watercolor painter returned from Britain. He often viewed and emulated Mr. Guan's works and got instructions and encouragement. The influence of Mr. Guan on Mr. Tian's artistic ideology and painting techniques was significant and laid a solid foundation for his life-long creation of watercolor painting. He made friends with other painters of Li Jianchen, Zhang Chongren, Wang Maigan, Meng Muyi, Ma Baishui, Cui Jiasheng, Wu Chenglu and Zhao Chunxiang. During that period, he held a few individual or joint exhibitions of painting in Beijing, Xi'an and Shanghai. His painting of *The Family of Worker and Farmer* was displayed in the first national art exhibition in 1949. He became a member of Shanghai Association for Artists in the same year. He, Wang Maigan and Meng Muyi joined No. 5 Corps of the 2nd Field Army and went southwards to Guizhou in October of 1949. He was appointed head of creation teams in Guizhou Provincial Cultural Circle and Guizhou Pictorial, as well as teacher of art departments in Guizhou University and Guiyang Teachers College. When Mr. Tian worked in Guizhou, local scenes were reflected in his paintings, for example, *Spring Comes* selected by national watercolor and sketch in

1954, *Path in Forest Area* and *Morning of Dong Village* listed on national art exhibition respectively in 1958 and 1960, *Lumbering* chosen for national art exhibition in 1964. Owing to the "cultural revolution" in 1967, Mr. Tian was forced to stop his creation of watercolor painting. At the end of the "cultural revolution", he restored his creation and painted a lot of good pieces with his passion for beauty.

With beautiful scenery, colorful customs and temperate climate, Guizhou is suitable for watercolor painting. For scores of years, Mr. Tian has a tight bound to Guizhou where he admires the cultural diversity. He has been indulged in stone house of the Buyi ethnic group and pole-supported wooden house of the Dong and Miao. A plenty of his late important watercolor paintings come from stone house of the Buyi and pole-supported wooden house and covered bridge of the Dong and Miao. His flagstone, mountain, river, farmhouse, buffalo and smog have left a deep impression on us, for instance, selected works for national and Asian exhibitions like *The Miao Ethnic Group, Timely Snow in Dong Village, Clearing Up after Snow Stop, Having a Rest, Morning Fog on the Qingshuijiang River, At Noon, Mill* and *Silver Ornaments of the Dong*. Mr. Tian pays attention to sketching from nature with full of his feelings. "Vivid and creative, his watercolor paintings come from life, but higher than life." He has studied expression of natural light and color, as well as color of sketch from nature, and painted around a thousand watercolor sketches. Some of his sketches are high quality such as *Crossroads of Rongjiang County-seat, Boai Road of Guiyang, Return at Dusk, Stone House, Autumn, Bridge Market* and *Fog*. Particularly, I like to watch Mr. Tian paint on spot which is an enjoyment. Combining dry method with wet method, he stresses thin or thick color for his paintings to get an effect of water-color, bright-dark and dry-wet mixture. He is serious for his paintings, no matter in large or small sizes. He will choose different angles and honestly observe objects before he starts his works where he always has a clear relationship between his major object and other things. He will almost spend half time conceiving and will usually spend half day for a pencil draft of a building with a complicated structure. Mr. Tian took me for life drawing in villages of Southeast Guizhou in autumn of 1982 when he sketched about 100 watercolor pictures, of which *The Drum Tower of Dong Village* left me the deepest impression. Just a few hours later, the artistic effect and charming tune of drum tower, pole-supported house and colorful autumn jumped on the paper. I still have a fresh memory of that time. On the first day, Mr. Tian seriously depicted the structure of the building and its relation with others in different ways of line-light or heavy, void or solid, thin or thick. He began to give watercolor at the same time of the second day. He always put the color mixture aside for standby application in order to maintain the picture color and capture a general note. He would dash off the sky in a flash with a saturated brush. He had a good command of water and time. He painted freely on the wet background for distance view and drum tower, village when the paper was in half wet and half dry. Then he delineated house and pond. When the paper was wet, he would finish his close view quickly. Water seemed running on the picture which turned out to be transparent and delicate in a blending of water and color. He pursues transparency and freedom of water and color and focuses on one-time coloring to avoid overlap and repetition. Mr. Tian particularly likes to

paint flagstone house of Buyi village in Guizhou and has his uniqueness on flagstone-house watercolor landscape, which even becomes a symbol of his paintings. On this basis, he produced a lot of outstanding works such as *Buyi Family, Autumn Comes to Stone Village, Autumn Fruit, Sunlight of Stone Village* and *Petty Courtyard of the Buyi*. "He is skilled at his line, water and especially at his conception for his flagstone-house watercolor landscape. That is the reason why his watercolor is rare at home and famous for its taste from nature not for its texture."

Painting snow is his special point, too. Born in North China, Mr. Tian has natural and sincere feeling towards snow. His production of snow watercolor landscape derives from his personal experiences. As early as in the 1940s, Mr. Tian liked to paint watercolor landscape of snow. He would paint scores of snow pieces in Beijing and Xi'an every winter. Though it was seldom to snow in Guizhou, he would be excited to see snow. He had his understanding of watercolor snow landscape and found his own artistic language to express it, since he spent many winters in snow field. On the basis of inheriting traditional white space method, he adopted salt method to reinforce the special texture effect of snow. Mr. Tian painted snow pieces with great facility and high perfection. His watercolor snow landscape made viewers personally on the scene, vital and lively. For many years, some of his watercolor snow works were collected and selected for national watercolor exhibitions, for instance, *Snow Forest, Seasonal Snow in Miao Ethnic Village, End of Year, Snow-coated Village, Winter of Stone Village* and *Snow Path in Qianling Park*.

Mr. Tian's artistic and academic accumulation became richer and richer. His works reflected his life, his passion and formed his own language for watercolor. His contributions to watercolor were recognized by the artistic circle. His paintings were displayed from home and abroad, publicized and collected by the country. He was praised highly by his colleagues. Professor Huang Tieshan, director of watercolor committee of China Fine Arts Association, said, "Mr. Tian sets us a good example for his works and character. His works, rooted in life, reflect his real feelings-plain, natural and thought-provoking. Remarkably demonstrating watercolor characteristics -transparency and relaxedness, his paintings show beautiful color and consummate skills, which is significant for us to learn from." Professor Zhang Juyi, a renowned watercolor painter, mentioned in his letter "Mr. Tian devotes his life to watercolor and sets an example for us. It is not easy that his paintings, with rich flavor of life, can have a spiritual response from viewers. In addition, caring particularly about watercolor art itself, Mr. Tian always maintains a visual effect-purity, beauty and refreshment, which is too hard to understand at the moment for those who are good at exquisite workmanship. It is really difficult for Mr. Tian to still keep a free and easy style in his octogenarian age." A noted watercolor painter Bai Tongxu thinks that "Works of Mr. Tian are natural expressions of true feeling and genuine sentiment-simple, graceful, honest, free, refresh, enjoyable, bold and vigorous. His paintings fully exhibit features of watercolor. Many of his master pieces come from life drawing and are more vivid and more dynamic than those created indoors, and they have both accomplishment of English traditional watercolor and rich flavor of life." Professor Cui Yuzhang, a well-known watercolor painter, remarks after watching Mr. Tian's works, "He

has been to may mountains and rivers in the country and painted a lot of wonderful scenery, village and path, river and forest, snow and fog, ethnic customs, barked house and stone house. All these nice paintings offer us enjoyment of peace, beauty and attraction. His spirit of exploration and hard work has got him great achievements." Not a few famous watercolor painters at home give him high praises, such as Li Yongsen, Zhang Yinghong, Guan Weixing, Yuan Zhenzao, Wang Shuangcheng, Du Gaojie, Zhang Kerang, Pan Changzhen, Zheng Qimiao, Qi Deyan, Chen Shaoping, Fu Qizhong, Lin Rixiong, Liu Xinsheng, Zhu Hui, Gao Dong, Bai Die and Song Huimin. When approaching his old age, Mr. Tian feels important of the painting skills, but more important is the new concept and picture connotation. What he pursues for his watercolor is beauty on one hand, and conception on the other. Only he has got these two will he start. When he paints some time, he often stops to think over a while or studies works of others so as to get rid of his own limitations and try to find a new artistic means from different painting expressions.

Painting seems like man and man is like his paintings. Mr. Tian works hard to explore his watercolor art which is full of beauty and loved by people. To some extent, his watercolor has impressionistic style of Chinese painting; and his style is concise and plain, rich water and tasty color. Zhang Ding, former president of Central Academy of Art, and Wu Jiafeng, famous expert of western fine arts history and fine arts commenter, were moved after they viewed Mr. Tian's paintings. Mr. Zhang Ding repeated "good" for several times, "This gentleman has exquisite workmanship, down-to-earth and skillful. It's not easy. It's not easy!" Mr. Wu Jiafeng said: "His paintings are full of life. He has extraordinary skills and should not be neglected." It was rare for these two grand old men to speak favorably of a man of the same line in such high praise. Voluntarily, Mr. Zhang Ding gave his autograph as "Majestic, vigorous, serious and profound". Colleagues not only admire the true feelings, great simplicity, lively style and bold conception of Mr. Tian's watercolor paintings which are full of life, detailed expressive skill and great artistic attainment, but also pay respect to his moral quality, for he is modest, honest, sincere, amiable and affable. He sets an example for younger generations.

At the age of 88, Mr. Tian still paints industriously with vital creativity, which is just a reflection of his spirit. I often pay a visit to Mr. Tian. Each time when I drop in, I can have a pleasure to view his new works. Whenever we meet, we talk about watercolor art. He will not get any interest in exhibition, publication or painting sales. Except for his watercolor art, he pays no attention to fame or to money. That is the reason why I consider each meeting as a kind of impetus and encouragement.

I have two happiest things in my life. One is my research on biology, the other is my study of watercolor. I have always been influenced by Mr. Tian's integrity. It cannot be separate for me to have accomplishments today in watercolor and biology. I will take the opportunity to express my heart-felt gratitude and wish Mr. Tian to have more master pieces in his venerable age.

Wu Xingliang
Expert receiving special allowance from the State Council
2nd-grand Professor
October 18, 2011

目 录

序
吴良镛论绘画
主编的话
人如其画
——印象中的田宇高老师

	01 苗家树皮屋
32 锦屏春晓	02 西部民居
33 早晨的侗寨	03 晌午
34 小寨秋色	04 塔尔寺
35 雪晴	05 石寨阳光
36 山里人家	06 水乡初雪
37 小寨春初	07 雪原
38 鲁迅故乡	08 榕
39 清水江	09 林海晨雾
40 镇宁城门	10 老院
41 榕江街上	11 小镇集市
42 溪流	12 川东奉节
43 林区采运	13 阳光下的石寨
44 江南细雨	14 古榕
45 嘉峪关	15 石寨秋色
46 水乡周庄	16 山城
47 香纸沟之晨	17 院子里的阳光
48 侗寨人家	18 河岸民居
49 岁末	19 山村腊月
50 苗寨瑞雪	20 晨
51 雪林	21 首都风光——团城
52 石头寨的秋天	22 早春
53 待	23 侗乡银装
54 鱼	24 金秋
55 蟹	25 秋日
56 静物	26 石城早市
57 芍药	27 傍水人家
58 锅和蟹	28 侗寨鼓楼
59 苹果、石榴	29 布衣人家
60 布衣小院	30 绿水
62 灶台上	31 侗乡民居

CONTENTS

Preface
Comments on Paintings by Wu Liangyong
Words from Chief Editor
The Man, The Painting
—Impression of Mr. Tian Yugao

01 Barked House of the Miao Ethnic Group
02 Residence in the Western Region
03 Noon
04 Temple Tar
05 Sunlight of Stone Village
06 First Snow in Riverside Village
07 Snow Plain
08 Banyan
09 Morning Fog of Forest
10 Ancient Yard
11 Small Town Market
12 Fengjie of East Sichuan
13 Stone Village under the Sun
14 Age-old Banyan
15 Autumn of Stone Village
16 Mountain City
17 Courtyard Light
18 Residence on River
19 Last Month of Lunar Year in Mountain Village
20 Morning
21 Tuancheng-Capital Landscape
22 Spring Comes Early
23 Snow-coated Dong Village
24 Golden Autumn
25 Autumn Day
26 Morning Market of Stone City
27 Family on River
28 Ancient Building in Dong Village
29 Family of the Buyi
30 Crystal-clear River
31 Building of Dong Village
32 Spring in Jinping County
33 Moring of Dong Village
34 Autumn in Small Village
35 Clear and Fine after Snow
36 Mountain Family
37 Early Spring of Small Village
38 Hometown of Lu Xun
39 The Qingshuijiang River
40 Gate of Zhenning County
41 Crossroads of Rongjiang County-seat
42 Stream
43 Cutting and Transporting in Forest
44 Drizzling in South of the Yangtze River
45 Pass Jiayuguan
46 Zhouzhuang – Riverside Village
47 Morning of Xiangzhigou
48 Family of Dong Village
49 End of Year
50 Seasonal Snow in Miao Ethnic Village
51 Snow Forest
52 Winter of Stone Village
53 Waiting
54 Fish
55 Crab
56 Still Life
57 Chinese Herbaceous Peony
58 Pan and Crab
59 Apple and Pomegranate
60 Pretty Courtyard of Buyi
62 On Top of Kitchen Range

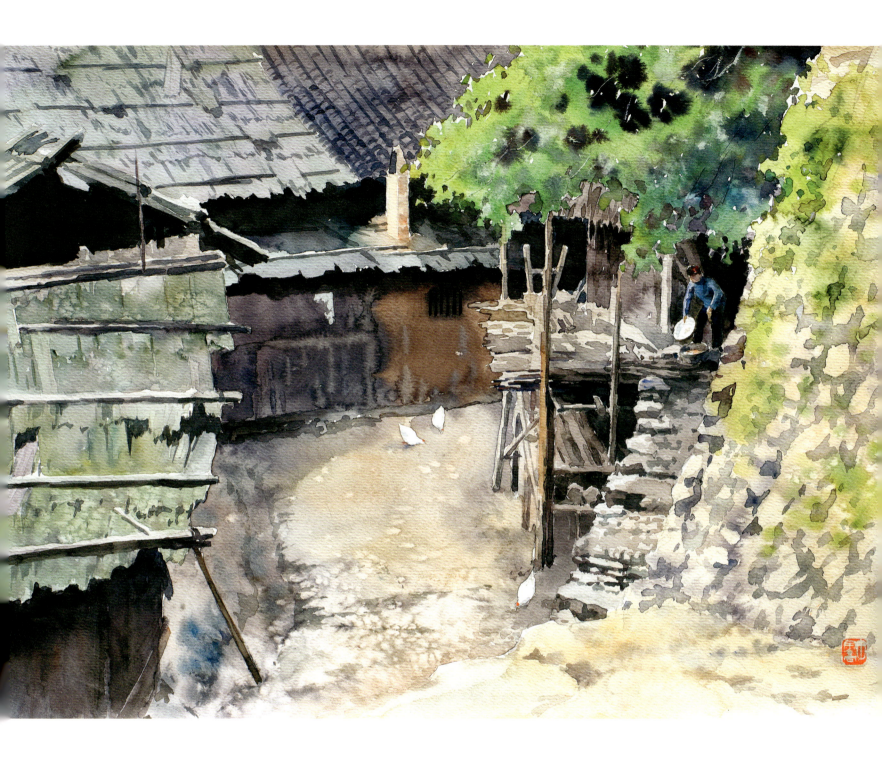

苗家树皮屋　38.5cm×53cm　1991年　‖　Barked House of the Miao Ethnic Group　38.5cm×53cm　1991

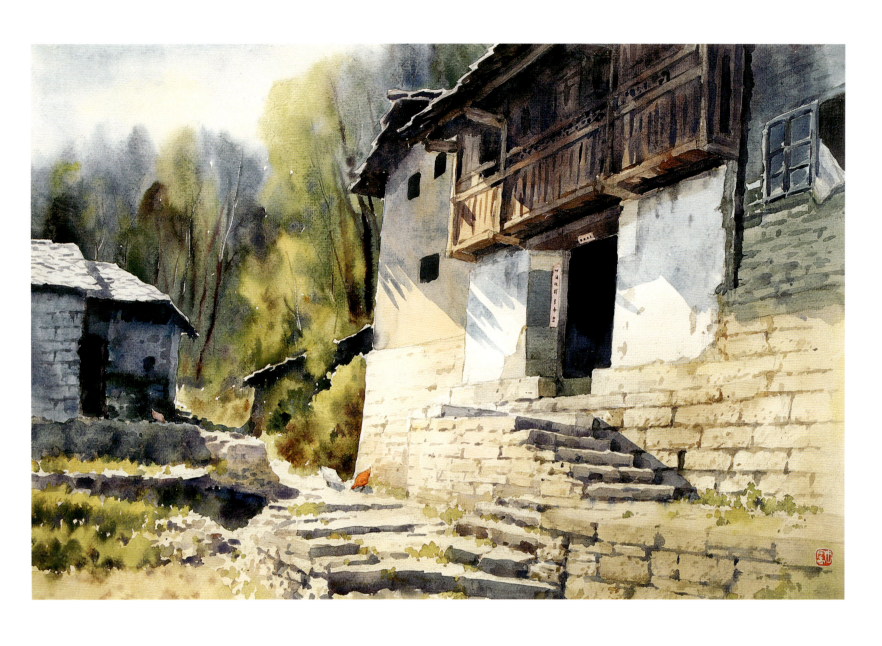

西部民居　75.5cm×50.5cm　2005年　‖　Residence in the Western Region　75.5cm×50.5cm　2005

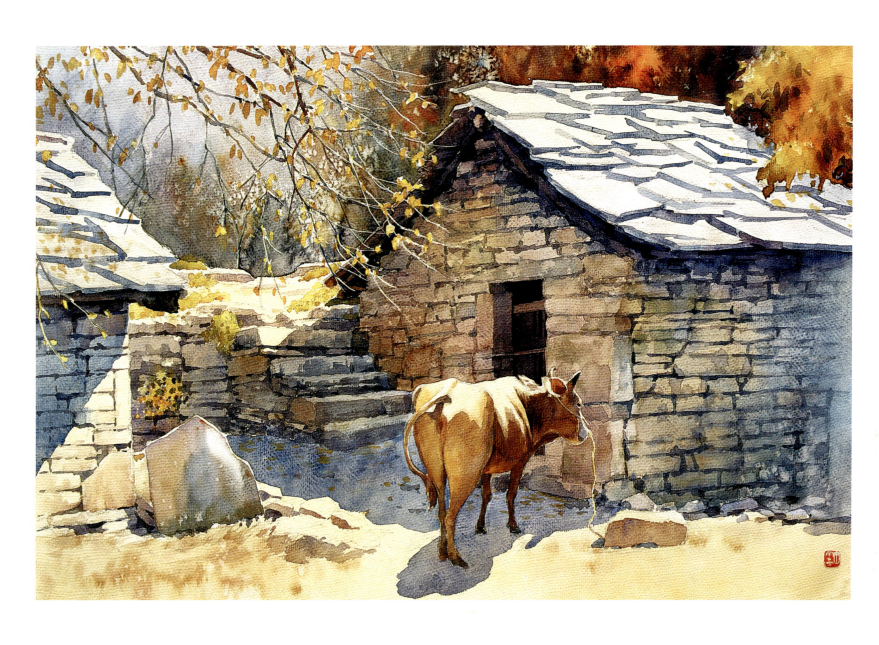

晌午　76cm×52cm　2000年 ‖ Noon　76cm×52cm　2000

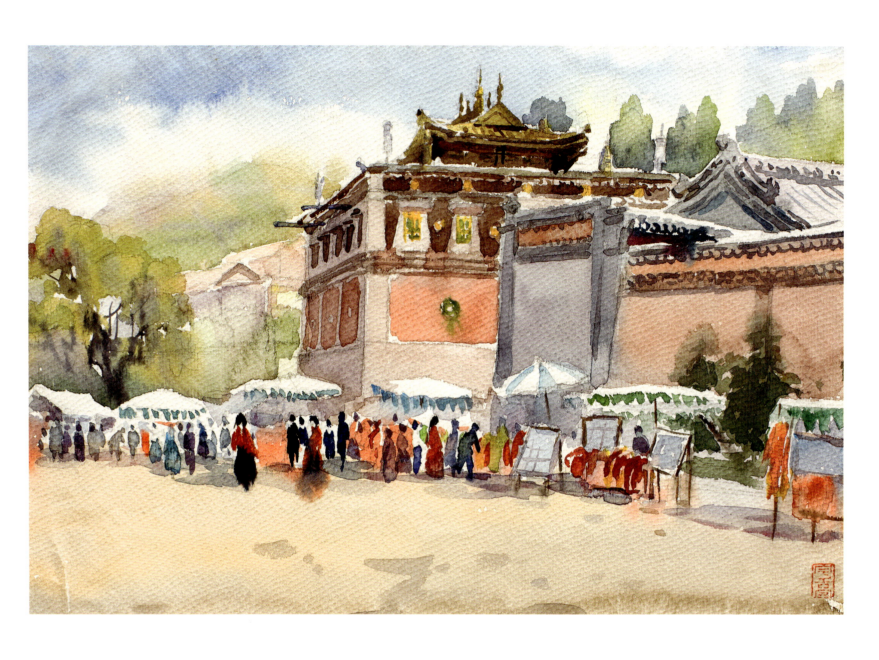

∧ 塔尔寺　30cm×36.2cm　1985年　‖　Temple Tar　30cm×36.2cm　1985

＞ 石寨阳光　38.3cm×31.2cm　1988年　‖　Sunlight of stone village　38.3cm×31.2cm　1988

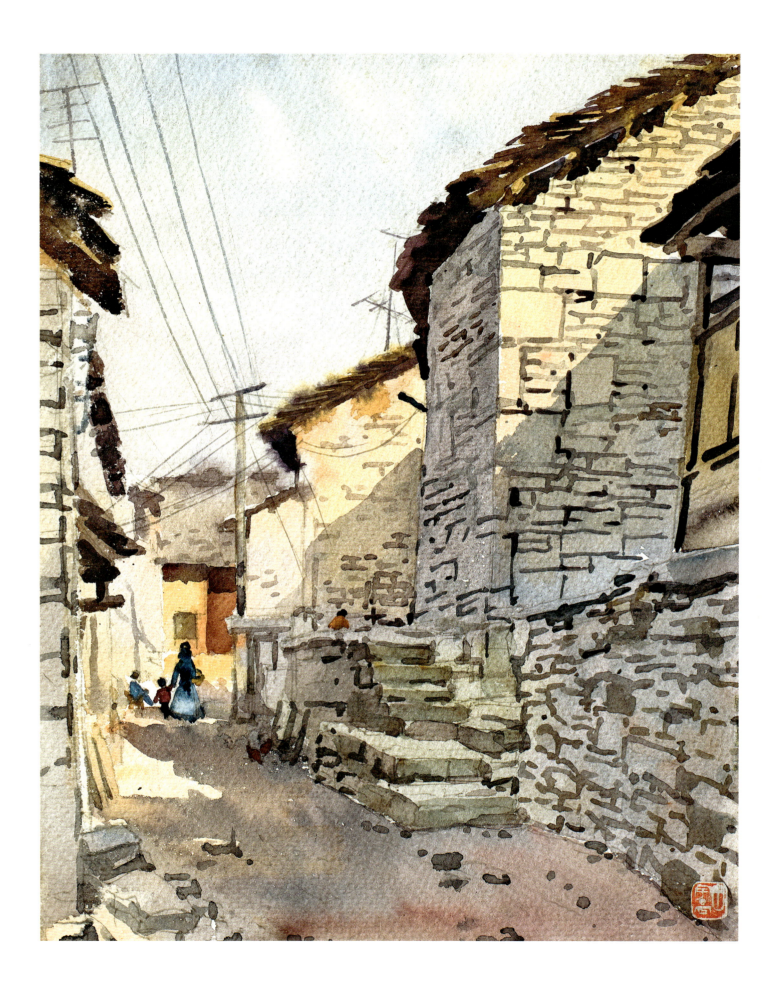

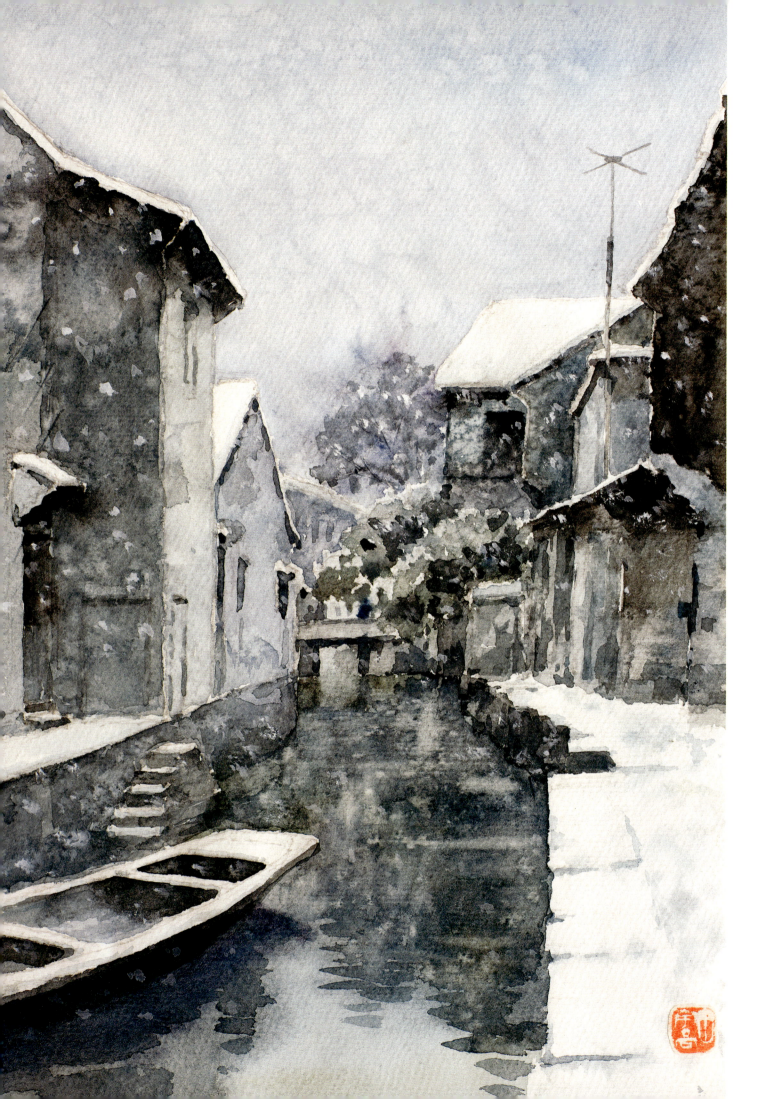

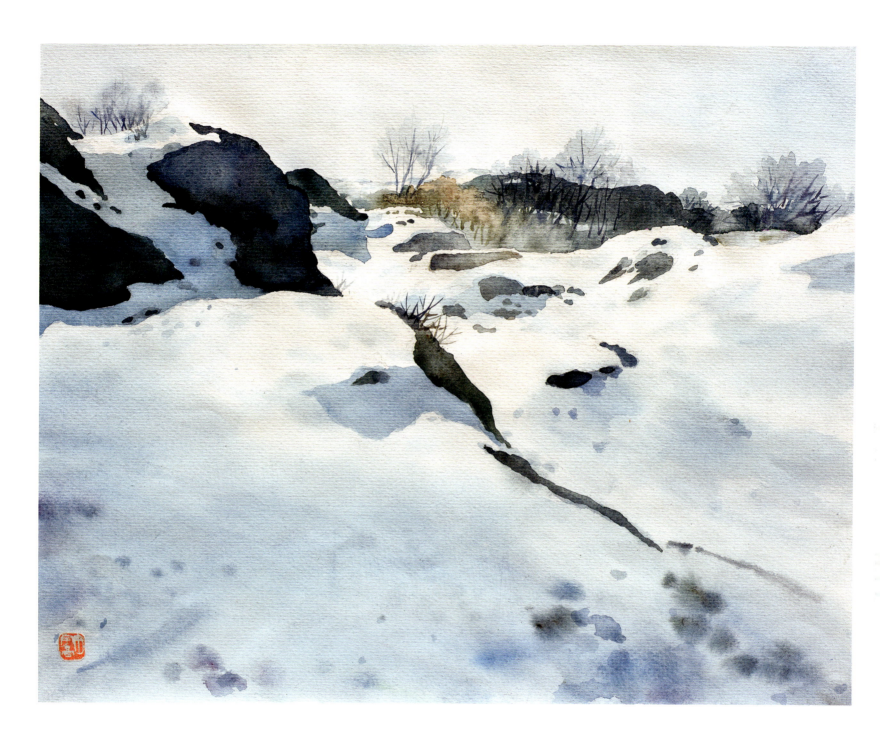

∧ 雪原　48.4cm×38.4cm　2003年　‖　Snow Plain　48.4cm×38.4cm　2003

< 水乡初雪　37.5cm×25.5cm　1992年　‖　First Snow in Riverside Village　37.5cm×25.5cm　1992

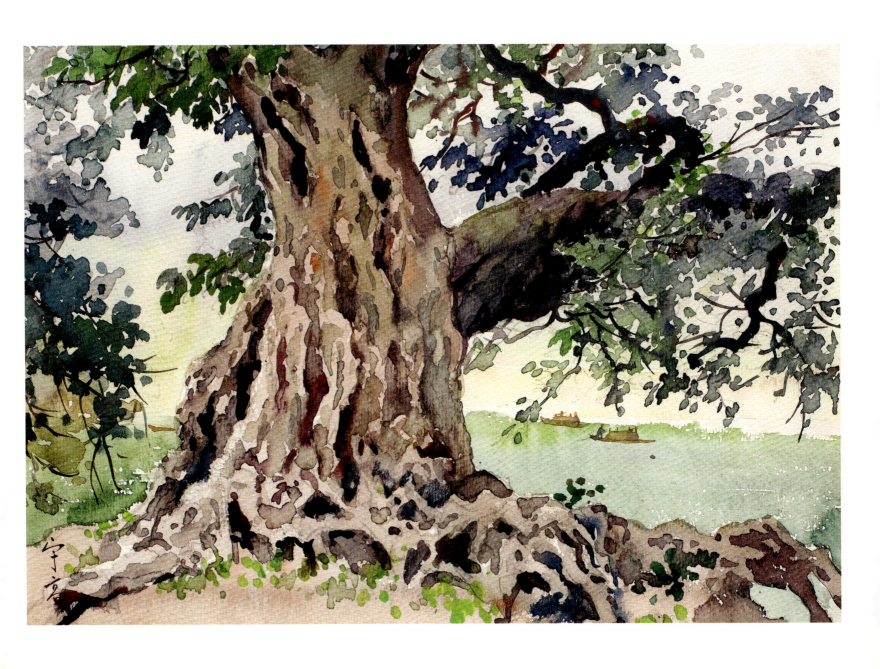

榕　37.5cm×26.8cm　1982年　‖　Banyan　37.5cm×26.8cm　1982

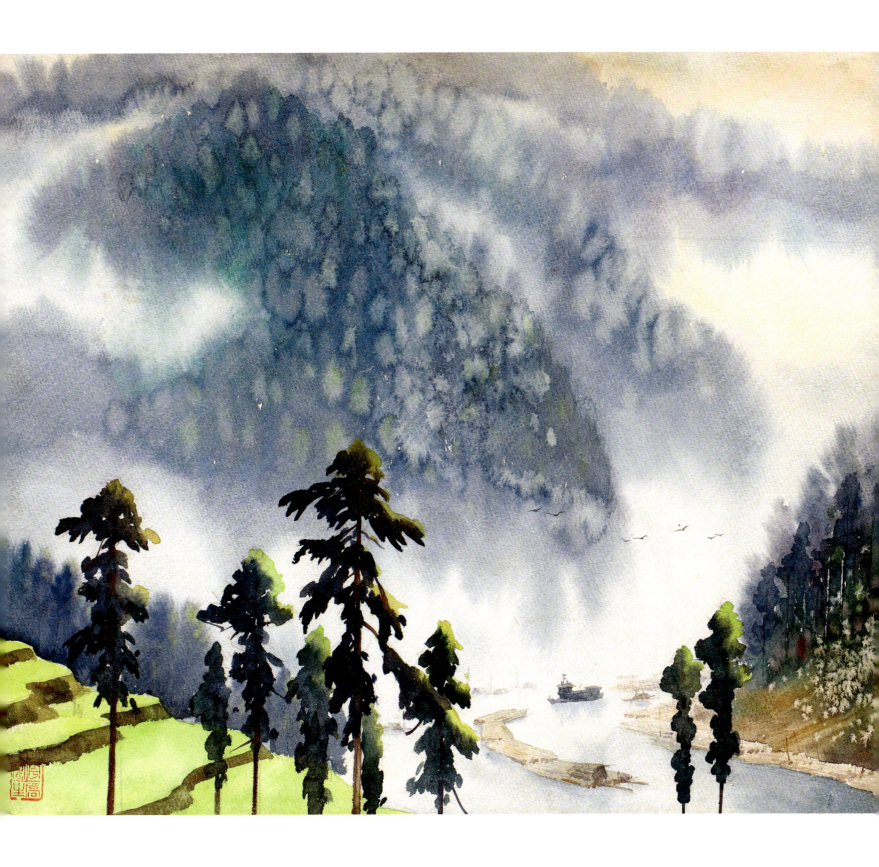

林海晨雾　53cm×42.2cm　1984年　‖　Morning Fog of Forest　53cm×42.2cm　1984

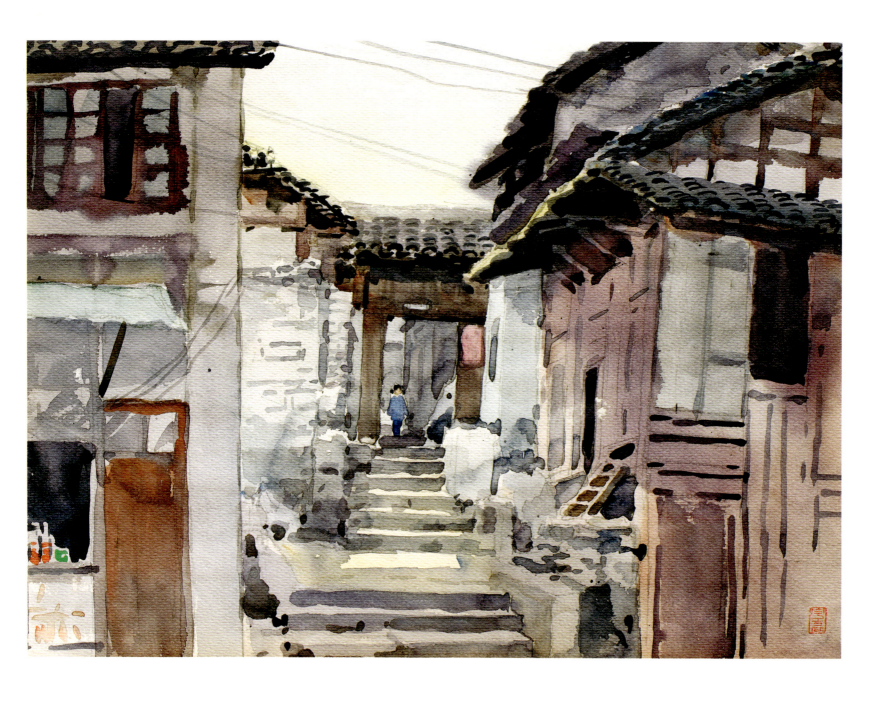

∧　老院　36.2cm×30cm　1985年　‖　Ancient Yard　36.2cm×30cm　1985

＞　小镇集市　38.7cm×28.5cm　1985年　‖　Small Town Market　38.7cm×28.5cm　1985

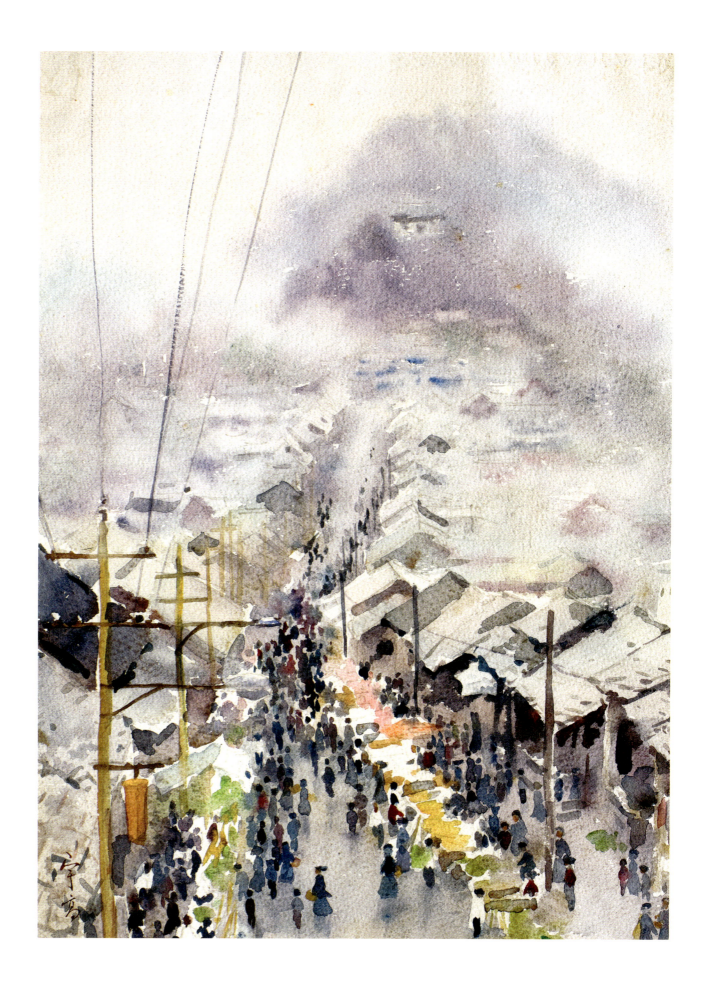

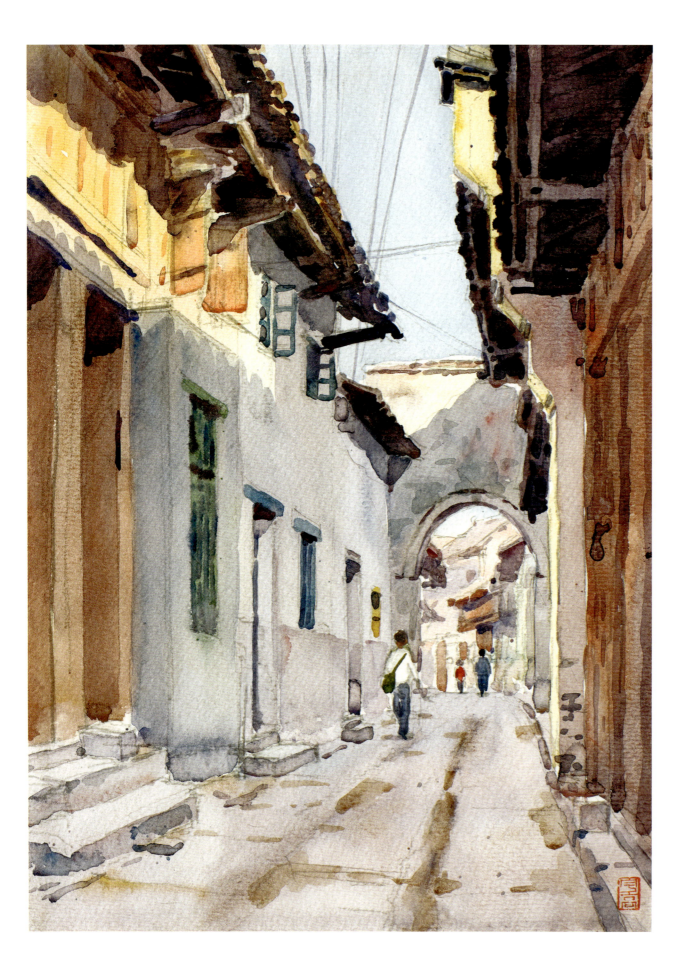

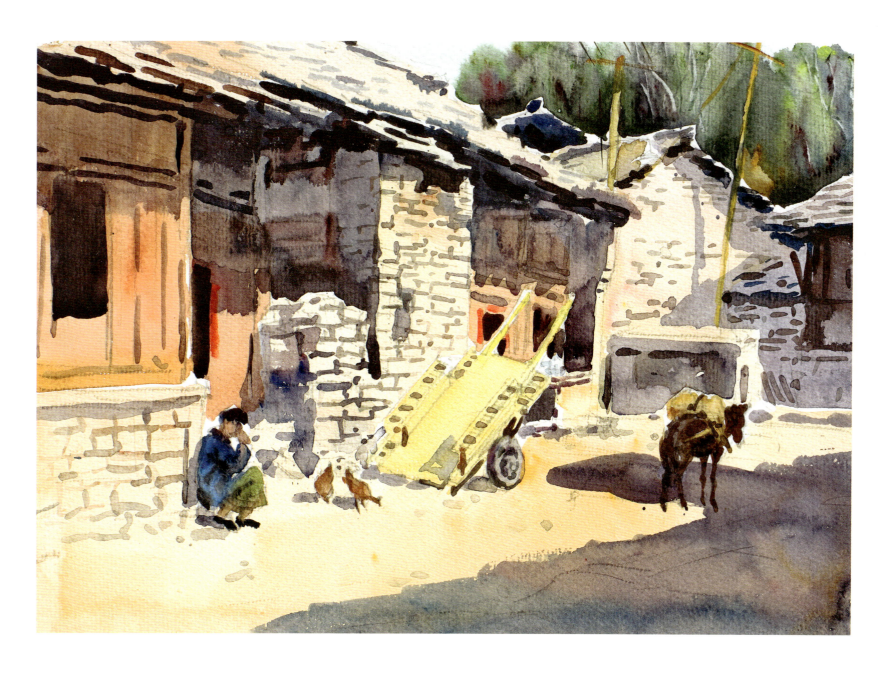

∧ 阳光下的石寨　43cm×31cm　1983年　‖　Stone Village under the Sun　43cm×31cm　1983

< 川东奉节　43cm×35.7cm　1987年　‖　Fengjie of East Sichuan　43cm×35.7cm　1987

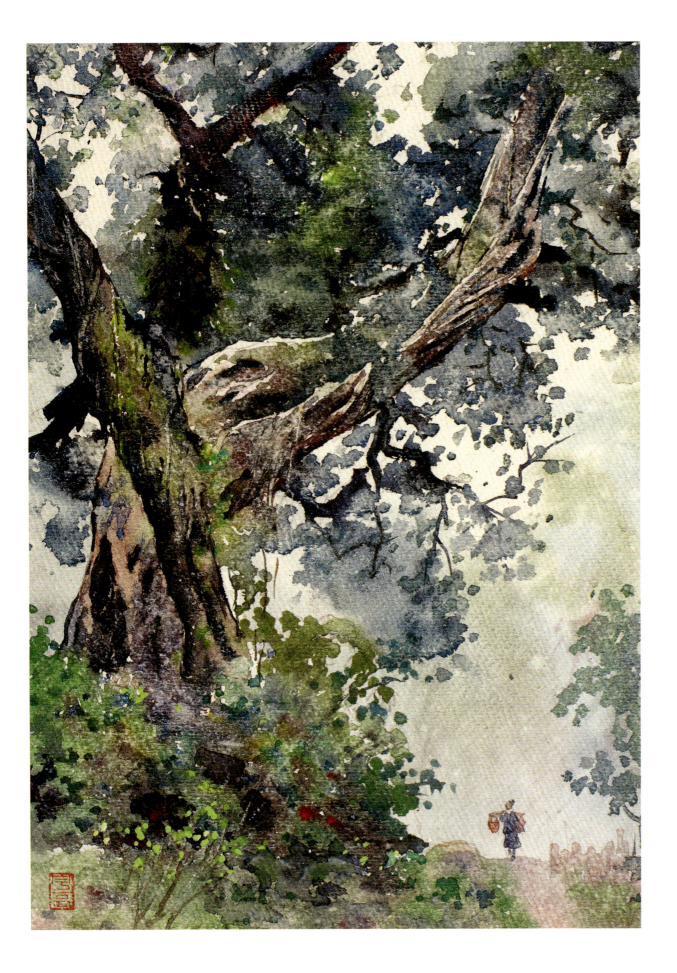

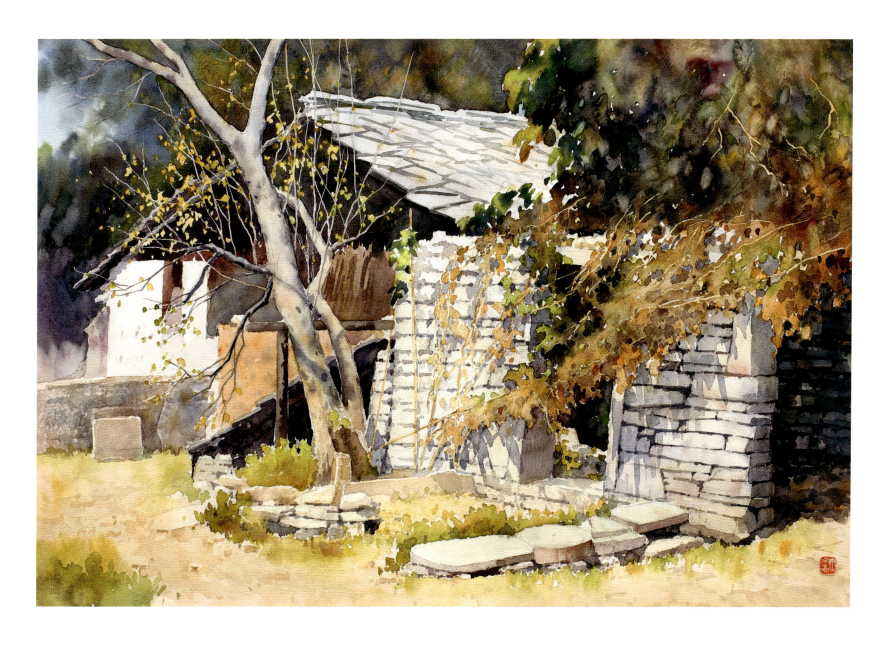

∧ 石寨秋色　76.8cm×51.7cm　2003年 ‖ Autumn of Stone Village　76.8cm×51.7cm　2003

< 古榕　38cm×26.5cm　1983年 ‖ Age-old Banyan　38cm×26.5cm　1983

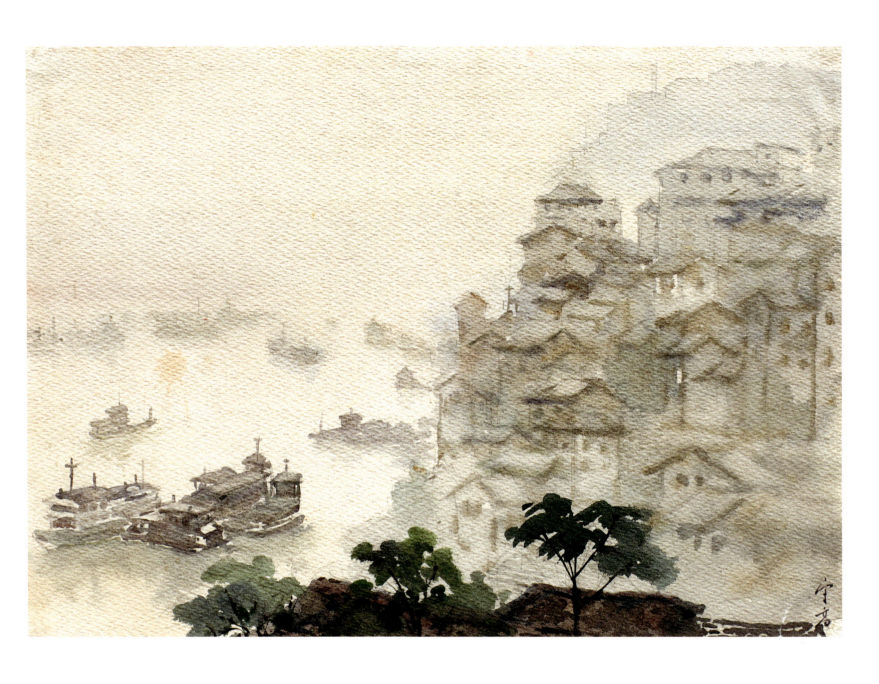

山城　42cm×29cm　1981年 ‖ Mountain City　42cm×29cm　1981

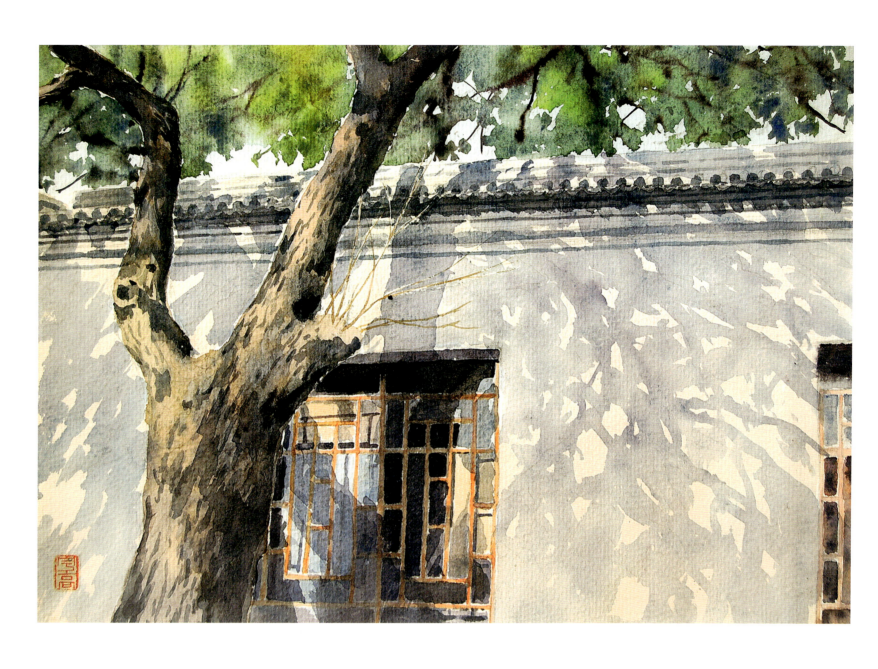

院子里的阳光　38.2cm x 53cm　2005年　‖　Courtyard Light　38.2cm x 53cm　2005

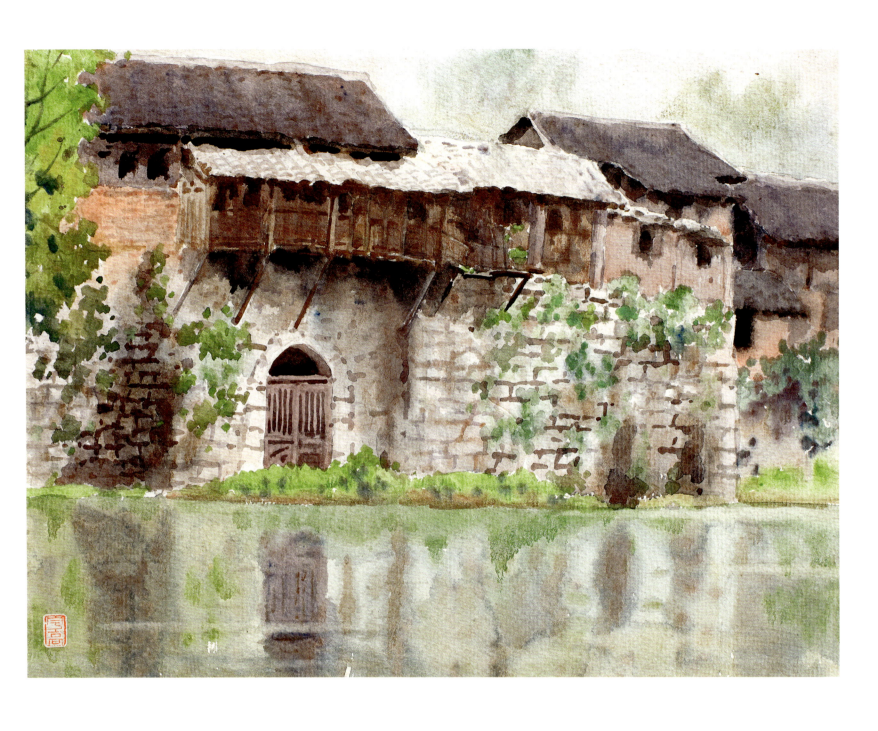

河岸民居　42.4cm×32cm　1989年　‖　Residence on River　42.4cm×32cm　1989

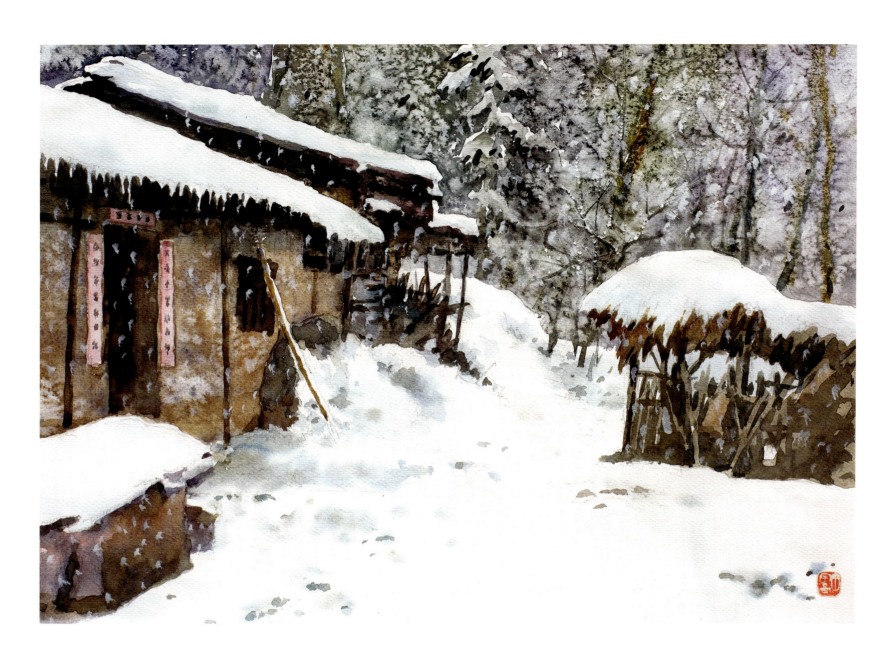

山村腊月　53cm×37.8cm　2008年　‖　Last Month of Lunar Year in Mountain Village　53cm×37.8cm　2008

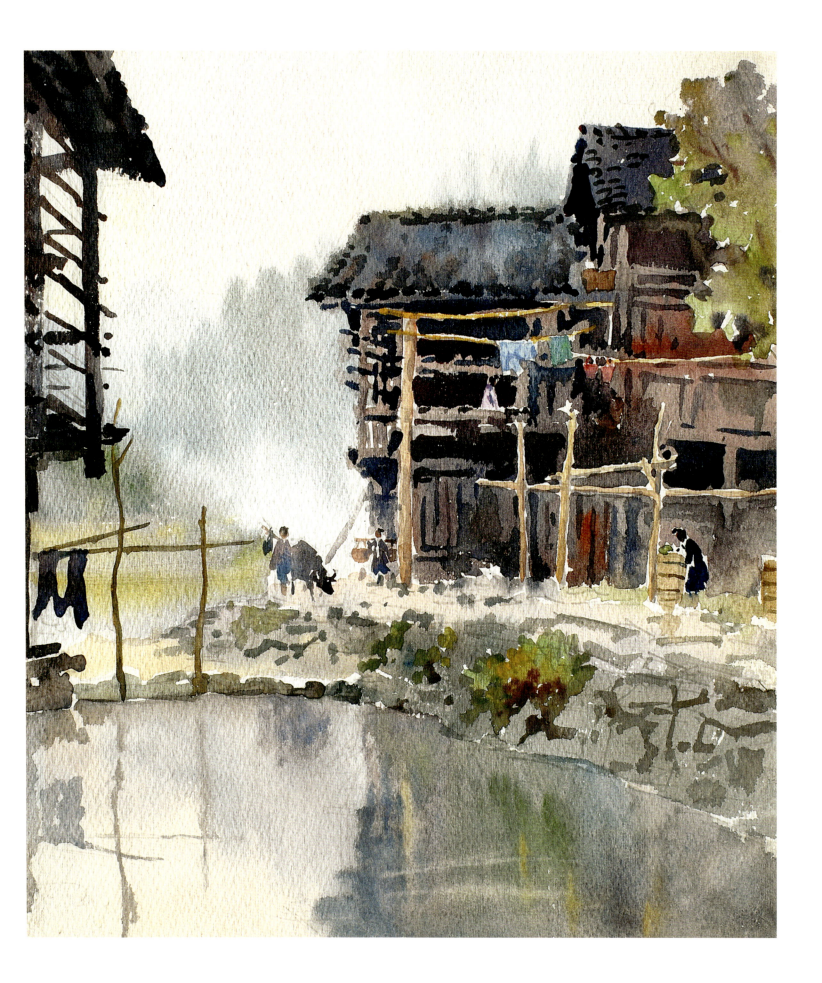

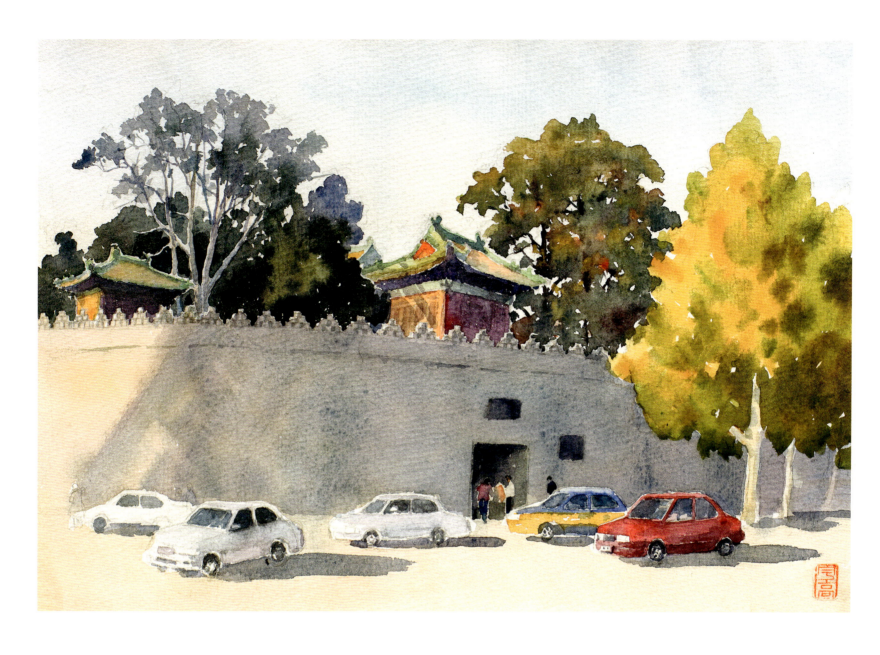

∧ 首都风光——团城　38.2cm×26.2cm　2006年　‖　Tuancheng—Capital Landscape　38.2cm×26.2cm　2006

< 晨　33.5cm×29.5cm　1981年　‖　Morning　33.5cm×29.5cm　1981

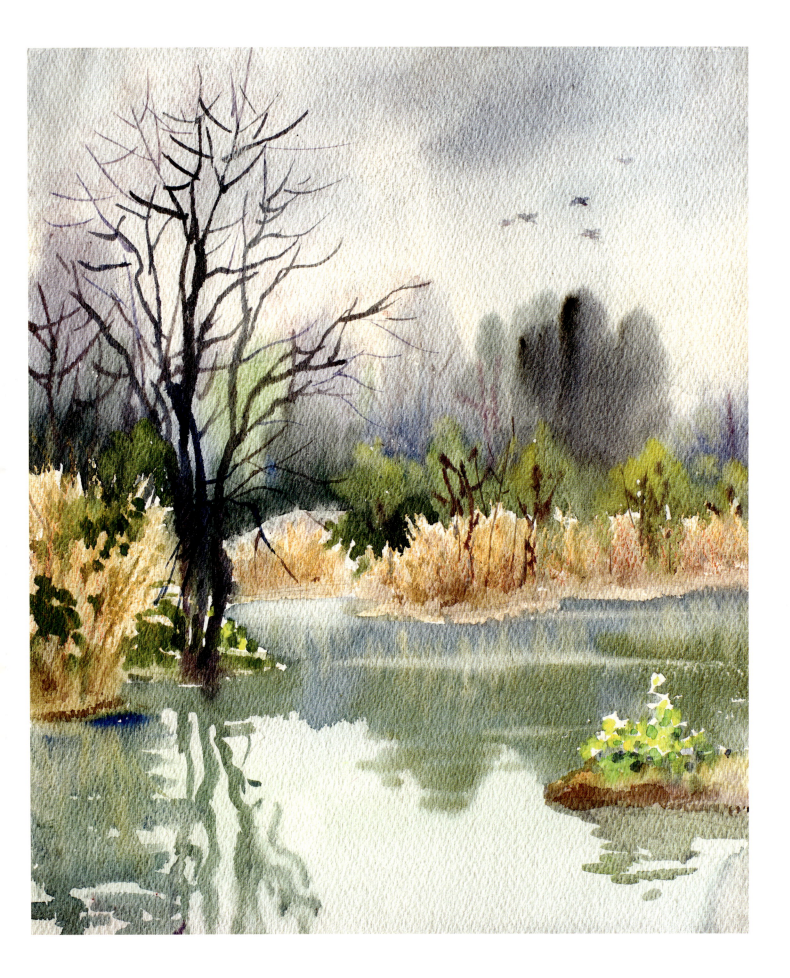

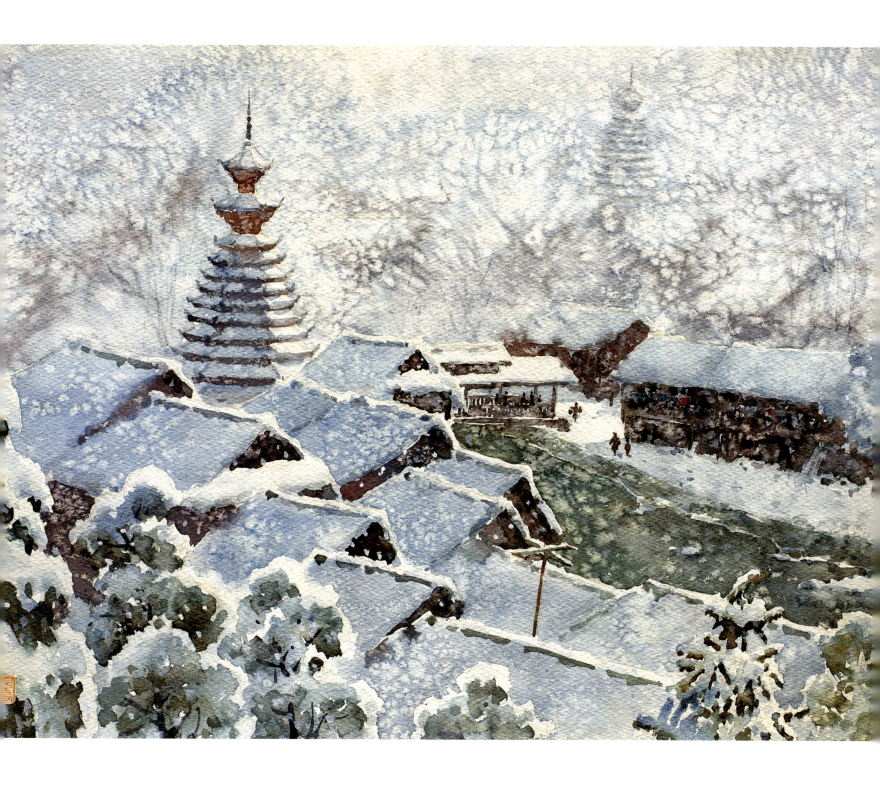

∧ 侗乡银装　41cm×54.3cm　1995年　‖ Snow-coated Dong Village　41cm×54.3cm　1995

< 早春　36.2cm×30cm　1985年　‖ Spring Comes Early　36.2cm×30cm　1985

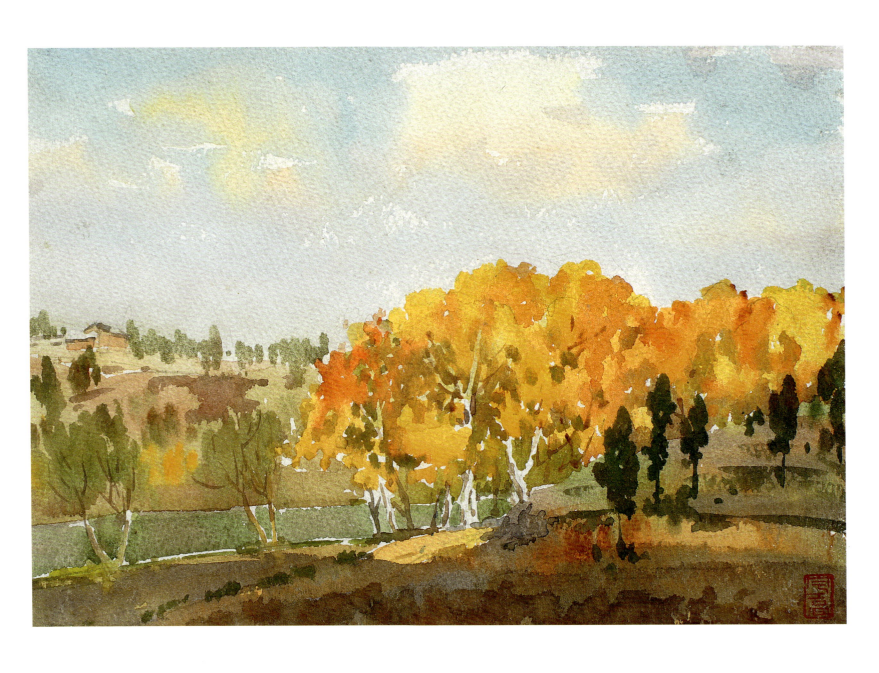

金秋　30.2cm×21cm　1985年　‖　Golden Autumn　30.2cm×21cm　1985

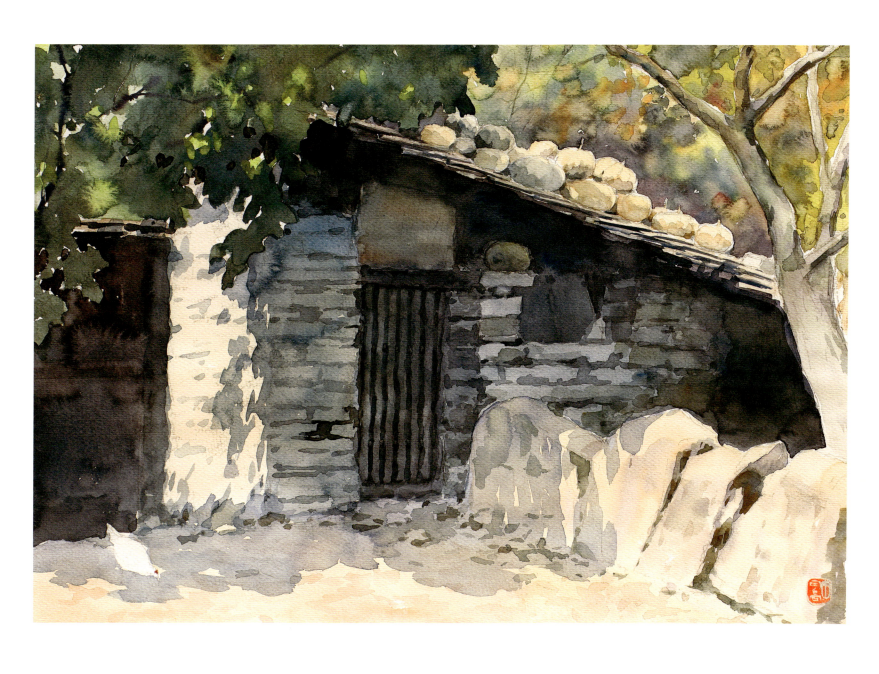

秋日　52.7cm×37.2cm　1992年　‖　Autumn Day　52.7cm×37.2cm　1992

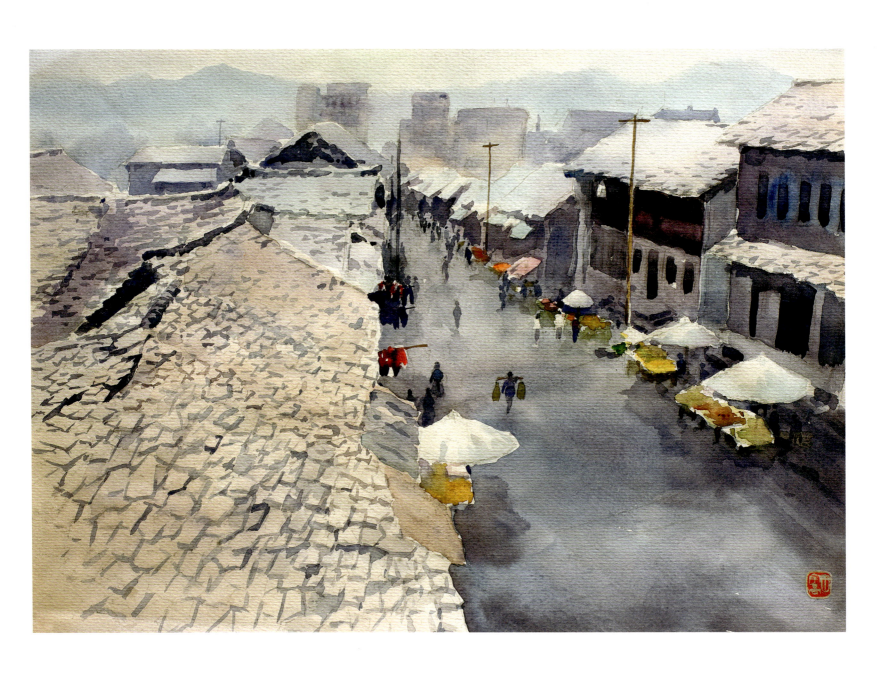

石城早市 53cm×38cm 2002年 || Morning Market of Stone City 53cm×38cm 2002

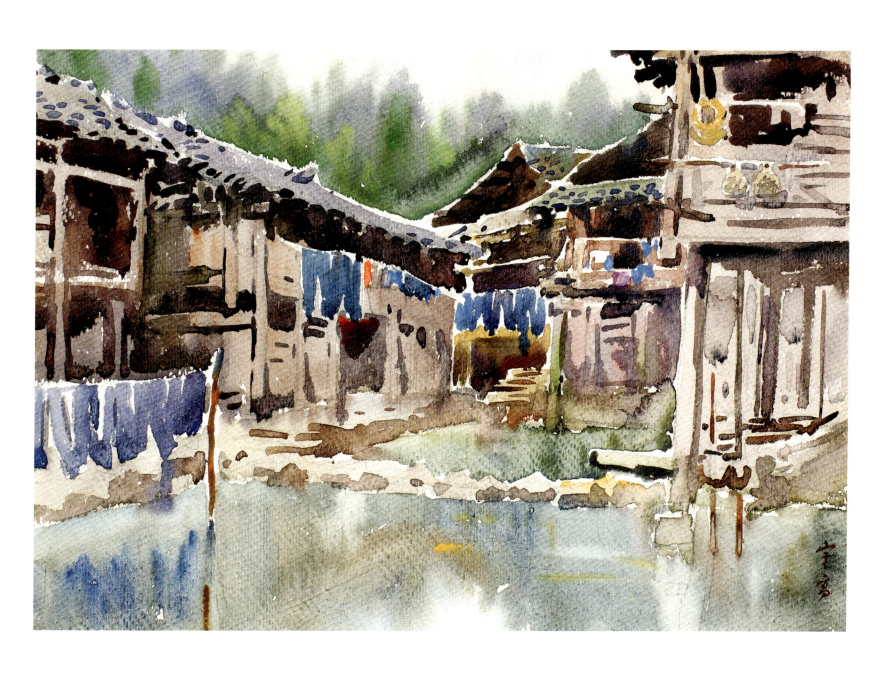

傍水人家　36cm×26cm　1980年　‖　Family on River　36cm×26cm　1980

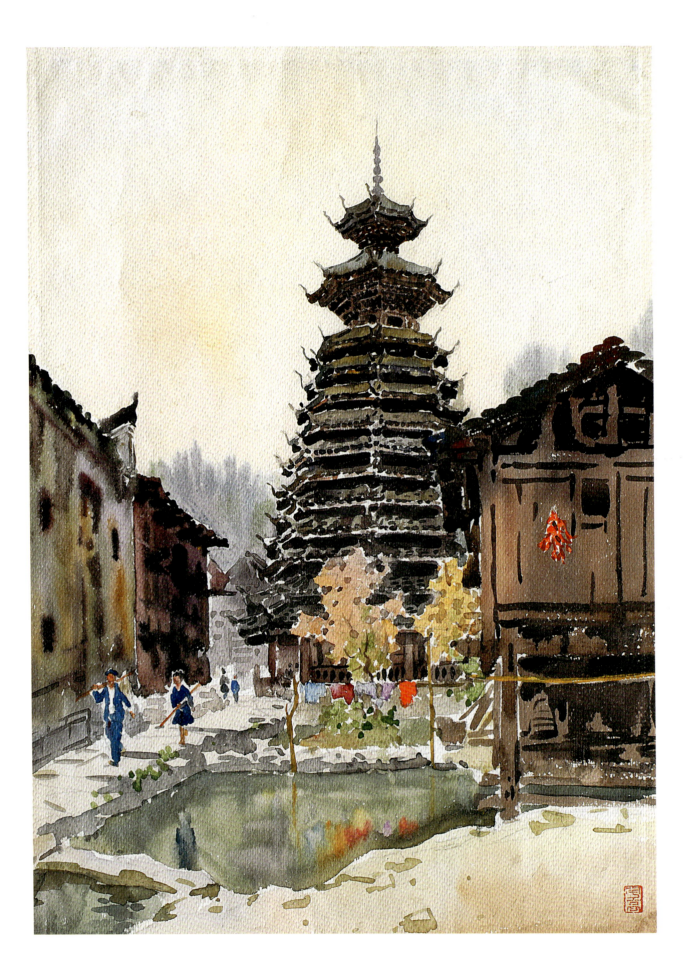

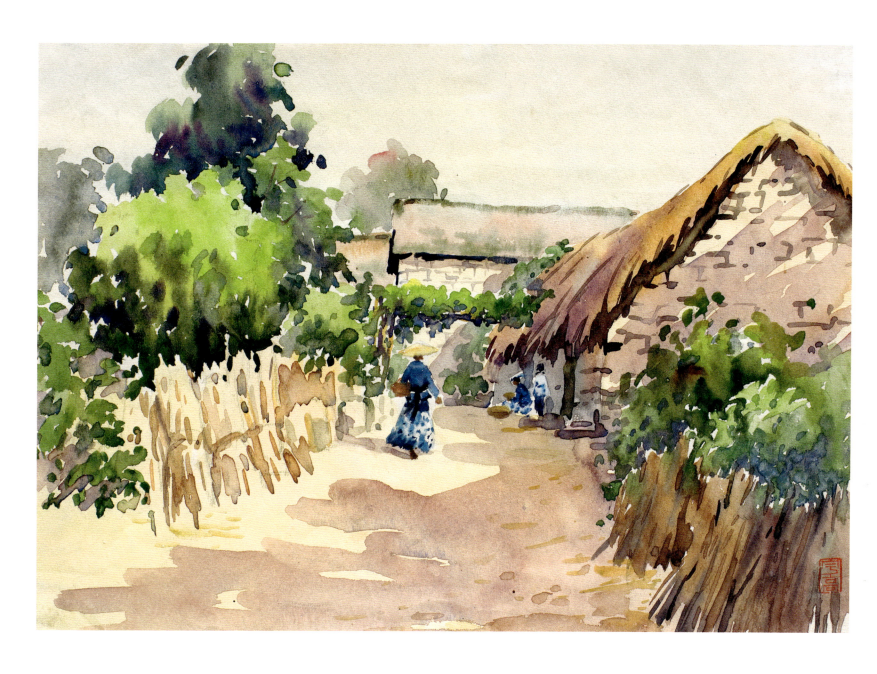

∧ 布衣人家　38cm×26cm　1962年　‖　Family of the Buyi　38cm×26cm　1962

< 侗寨鼓楼　51cm×37cm　1981年　‖　Ancient Building in Dong Village　51cm×37cm　1981

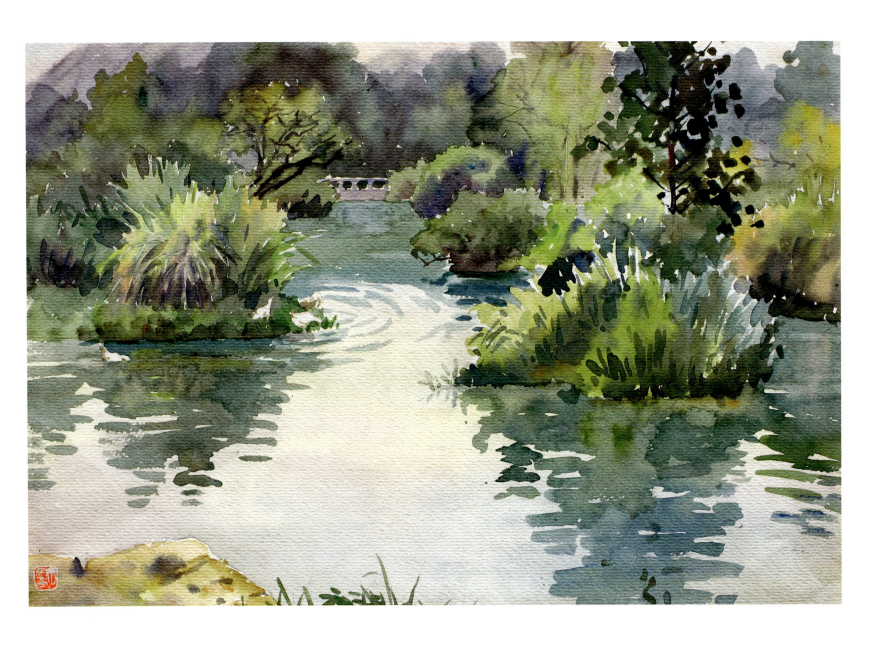

∧　绿水　57.3cm×38.7cm　1990年　‖　Crystal-clear River　57.3cm×38.7cm　1990

>　侗乡民居　38cm×28cm　2000年　‖　Building of Dong Village　38cm×28cm　2000

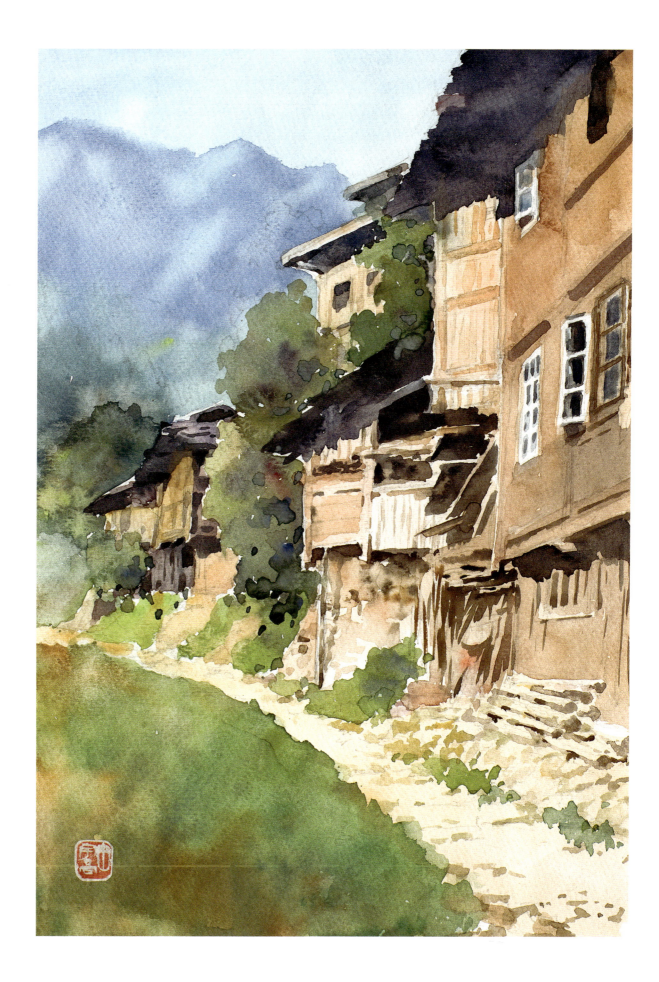

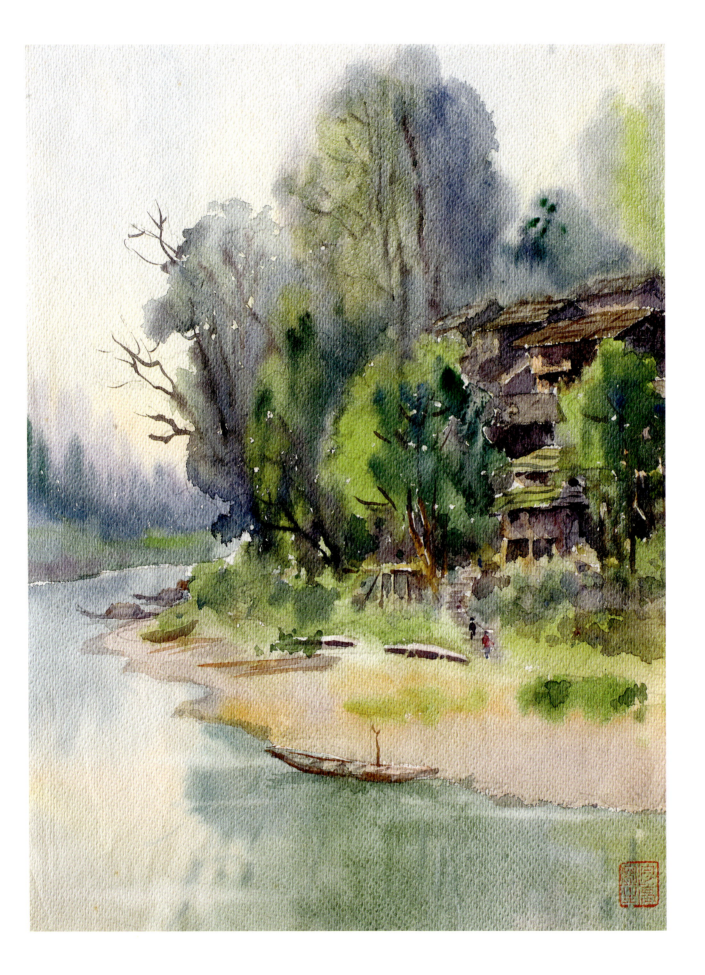

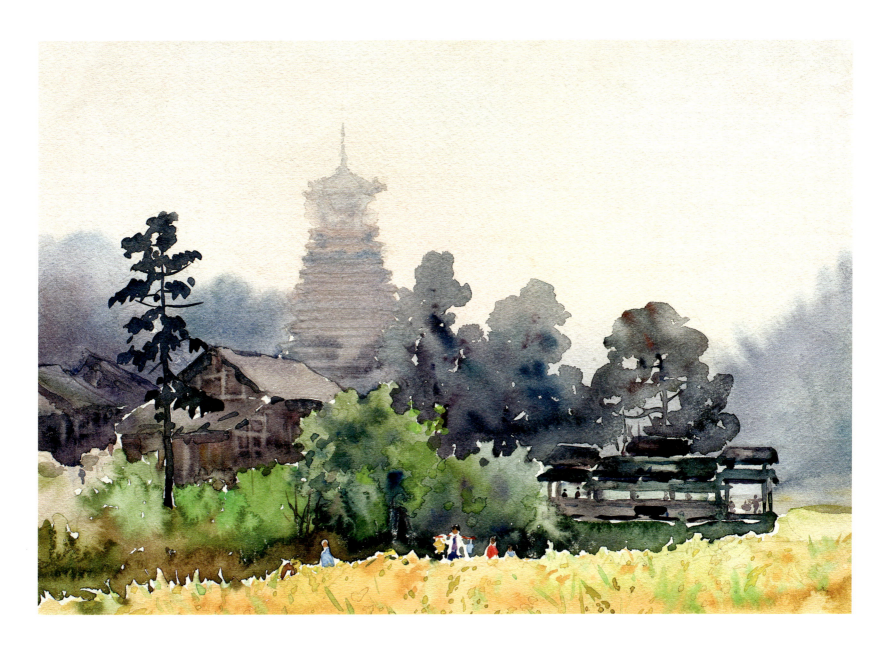

∧ 早晨的侗寨 38.5cm×26.3cm 1981年 ‖ Moring of Dong Village 38.5cm×26.3cm 1981

< 锦屏春晓 43.2cm×32cm 1985年 ‖ Spring in Jinping County 43.2cm×32cm 1985

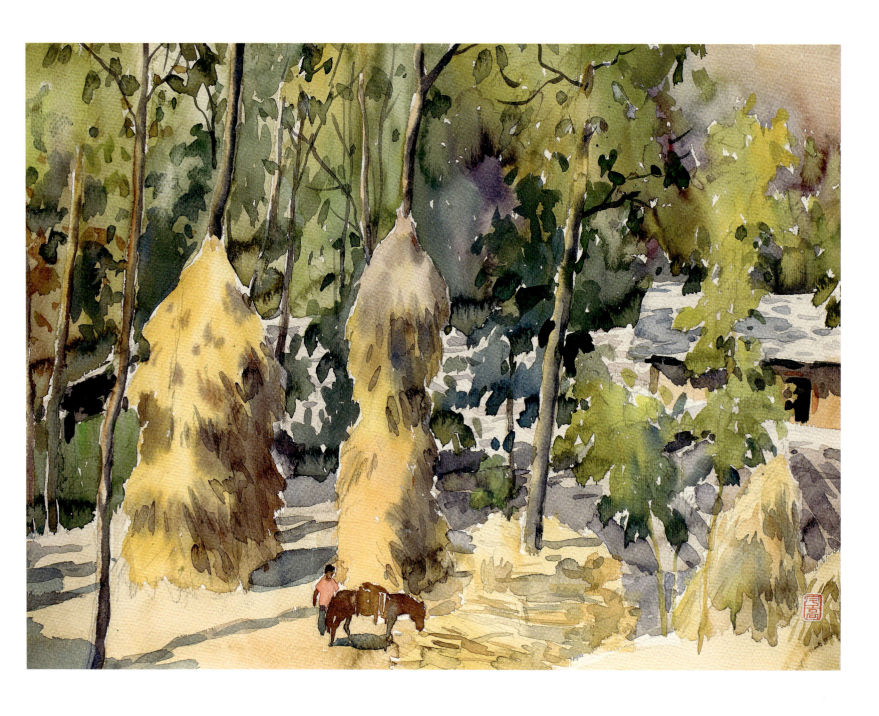

小寨秋色　51cm×38cm　1999年　‖　Autumn in Small Village　51cm×38cm　1999

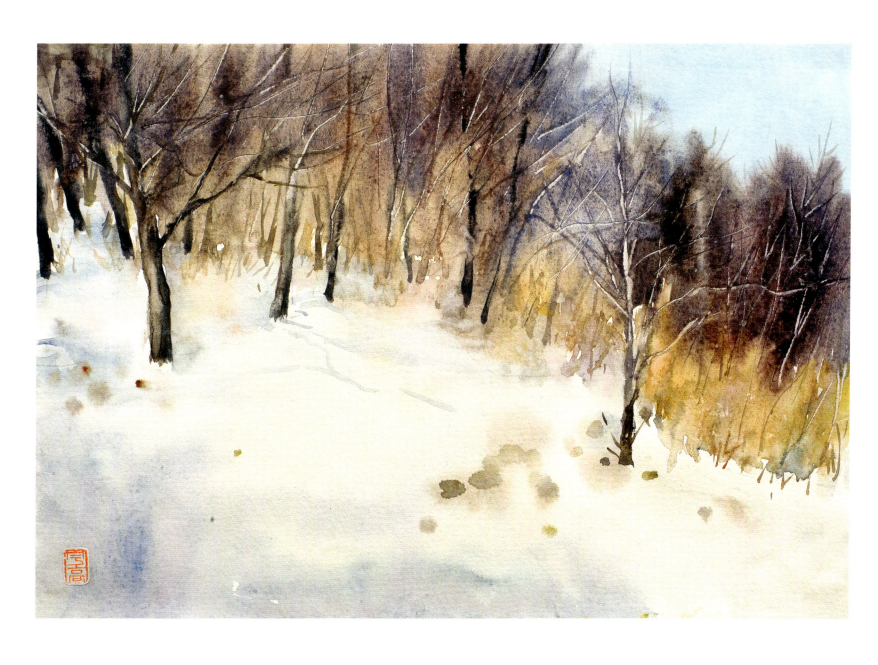

雪晴　38.7cm×26.3cm　2002年　‖　Clear and Fine after Snow　38.7cm×26.3cm　2002

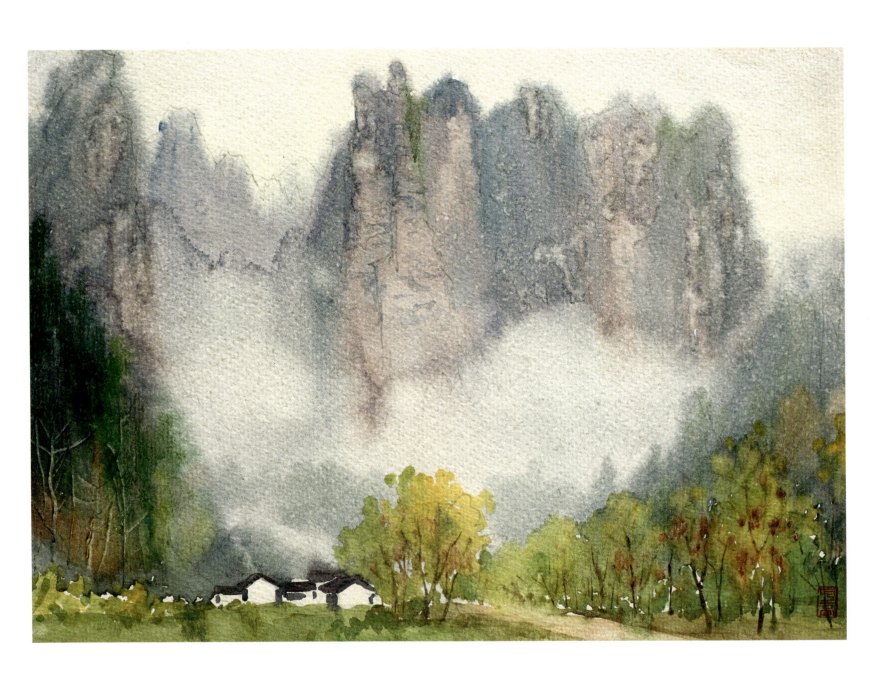

山里人家　42.6cm×29.6cm　1981年　‖　Mountain Family　42.6cm×29.6cm　1981

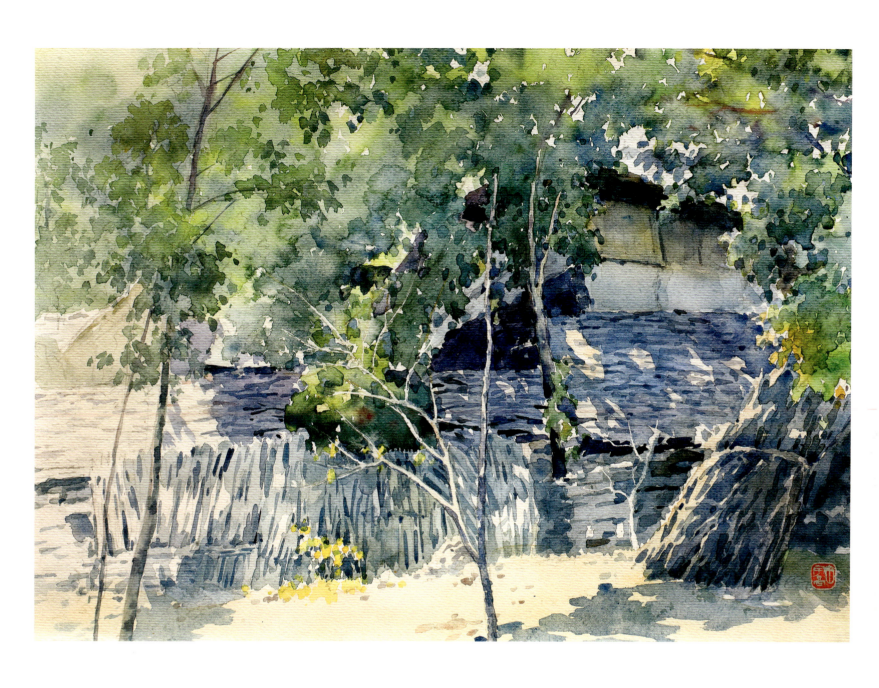

小寨春初　52.8cm×38cm　1995年　‖　Early Spring of Small Village　52.8cm×38cm　1995

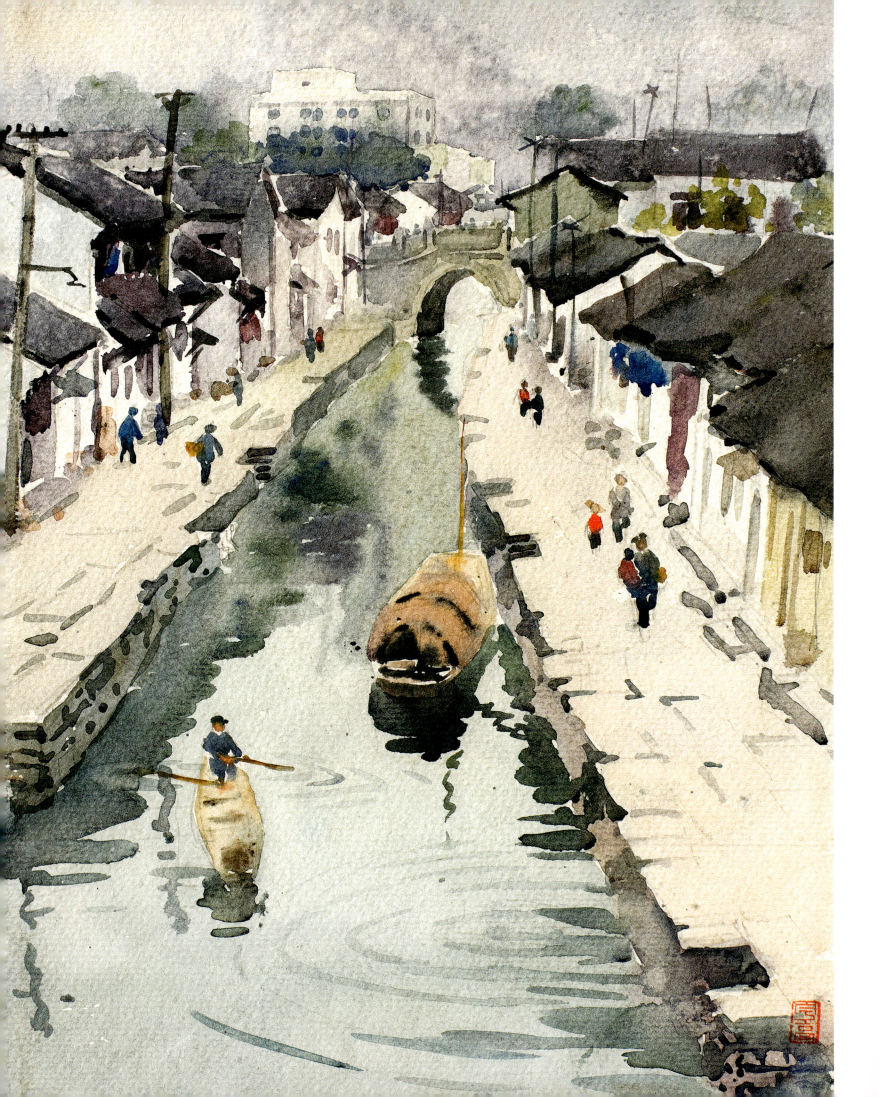

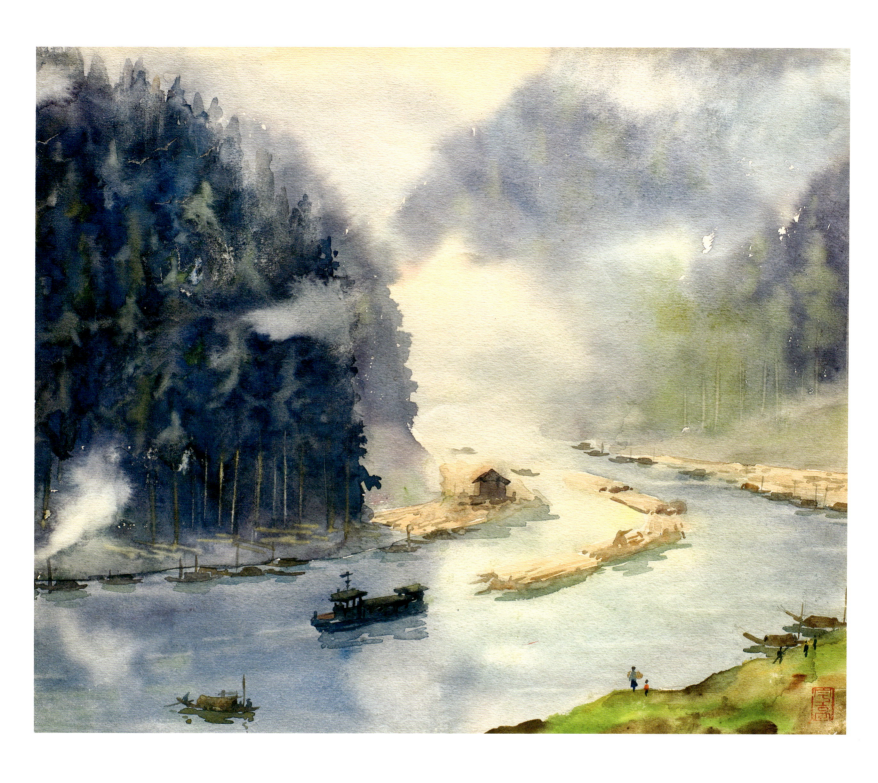

∧ 清水江　39cm×32cm　1964年　‖　The Qingshuijiang River　39cm×32cm　1964

< 鲁迅故乡　41cm×32cm　1986年　‖　Hometown of Lu Xun　41cm×32cm　1986

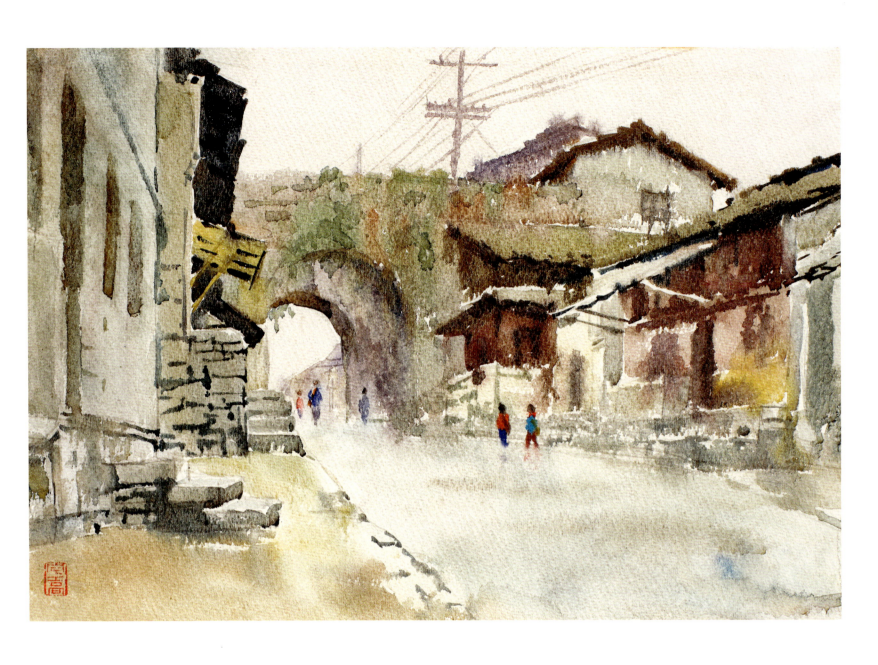

镇宁城门　37cm×25cm　1983年　‖　Gate of Zhenning County　37cm×25cm　1983

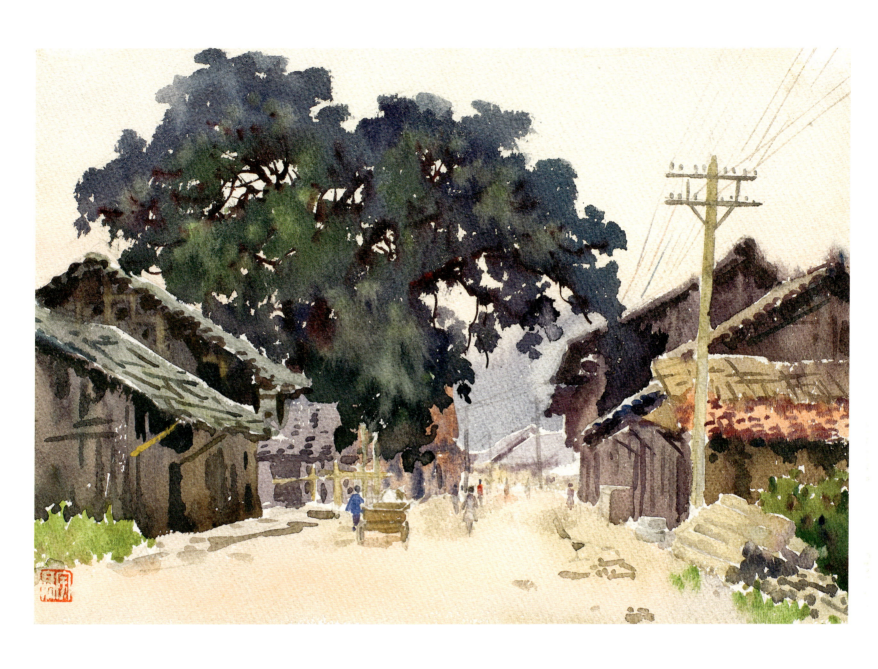

榕江街上　20.8cm×40.5cm　1982年　‖　Crossroads of Rongjiang County-seat　20.8cm×40.5cm　1982

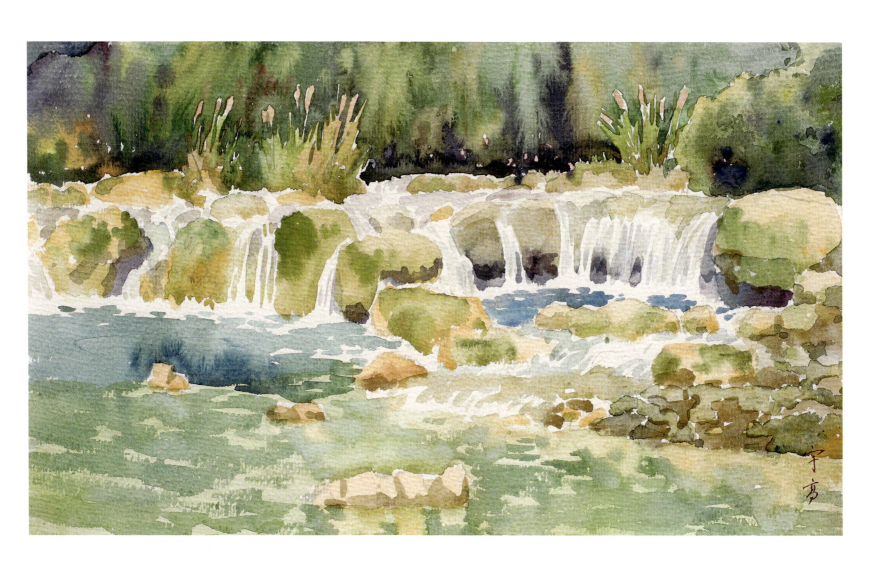

∧　溪流　38.7cm×22.5cm　1992年　‖　Stream　38.7cm×22.5cm　1992

＞　林区采运　38.5cm×26cm　1963年　‖　Cutting and Transporting in Forest　38.5cm×26cm　1963

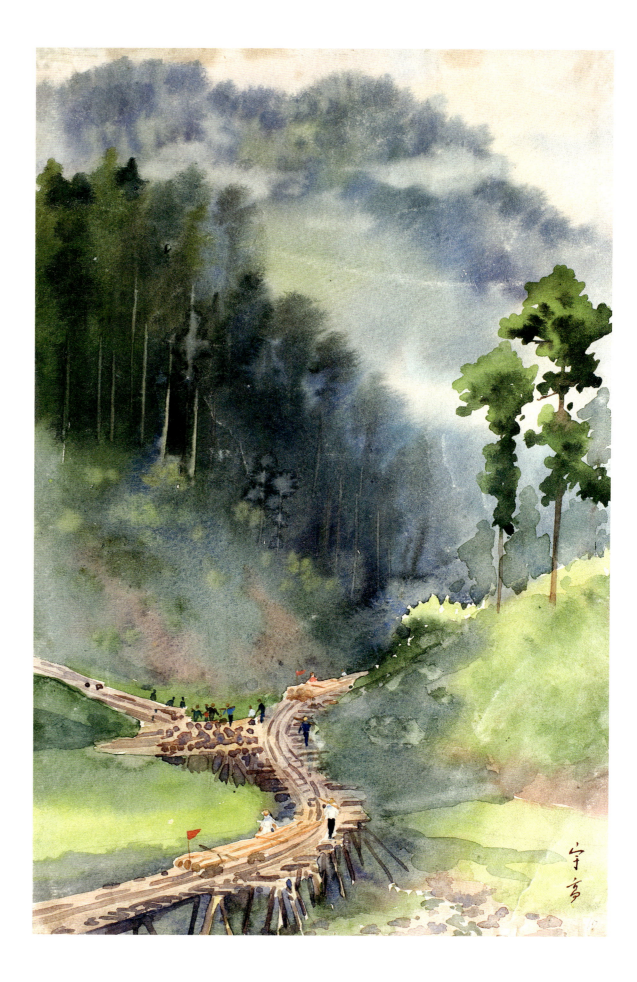

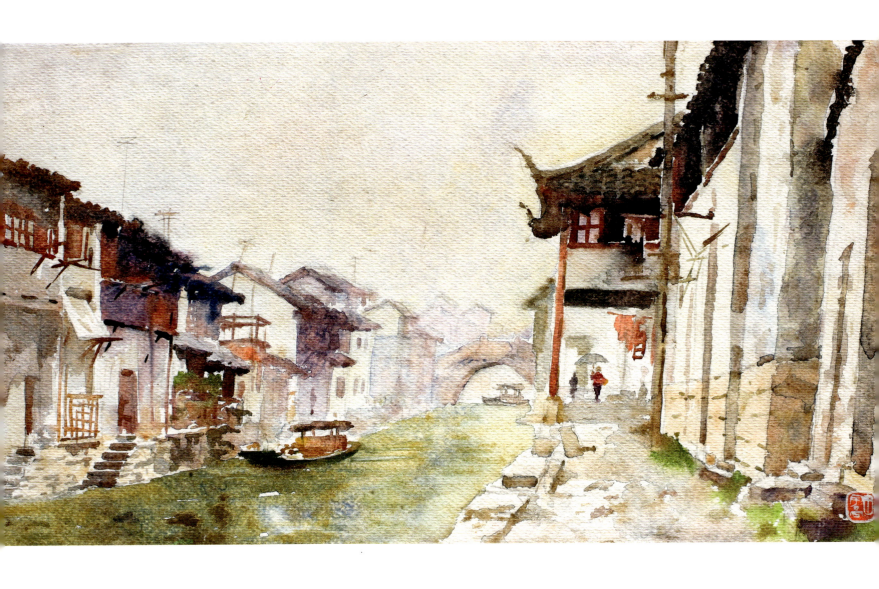

江南细雨　53cm×28cm　1989年　‖　Drizzling in South of the Yangtze River　53cm×28cm　1989

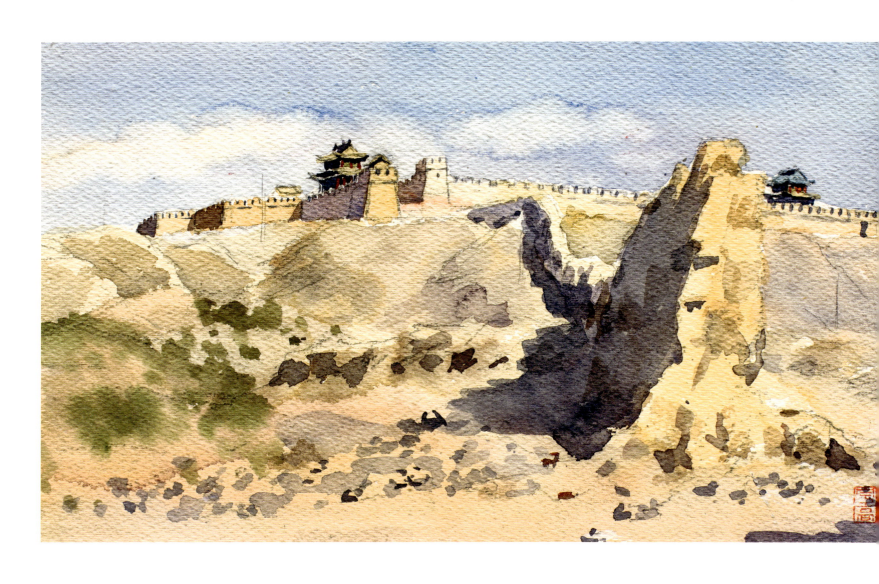

嘉峪关　38.3cm×22.4cm　1985年　‖　Pass Jiayuguan　38.3cm×22.4cm　1985

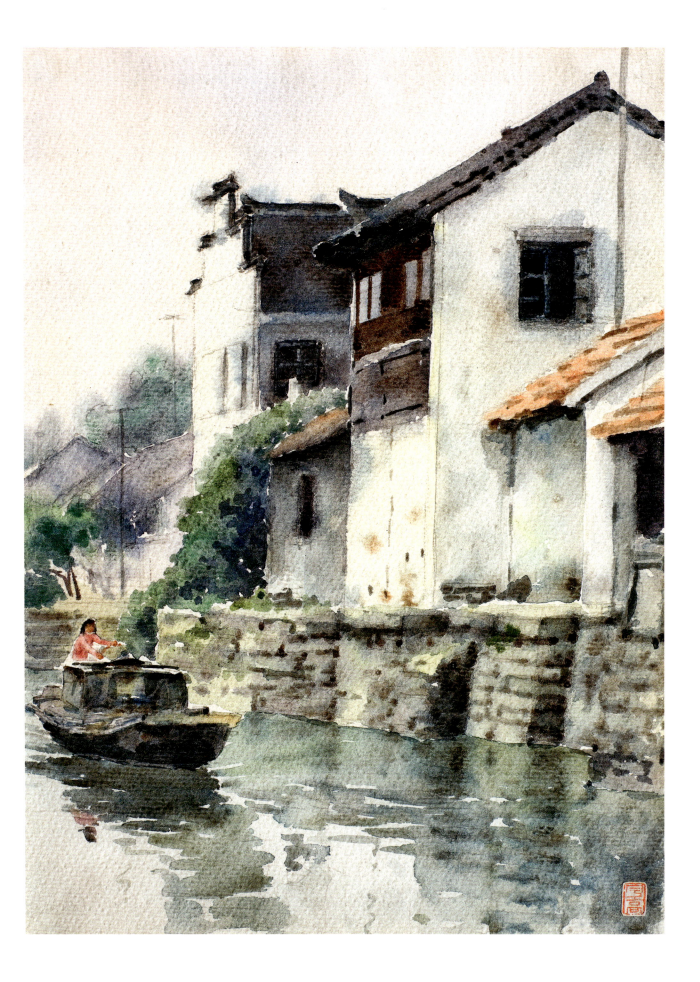

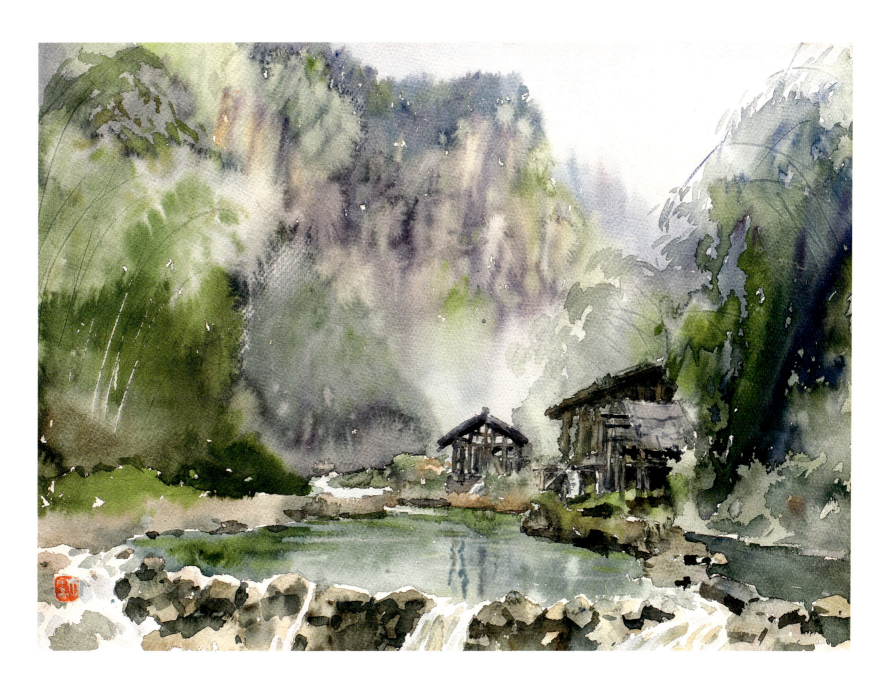

∧ 香纸沟之晨　52cm×38.2cm　1997年　‖　Morning of Xiangzhigou　52cm×38.2cm　1997

< 水乡周庄　43cm×32cm　1992年　‖　Zhouzhuang – Riverside Village　43cm×32cm　1992

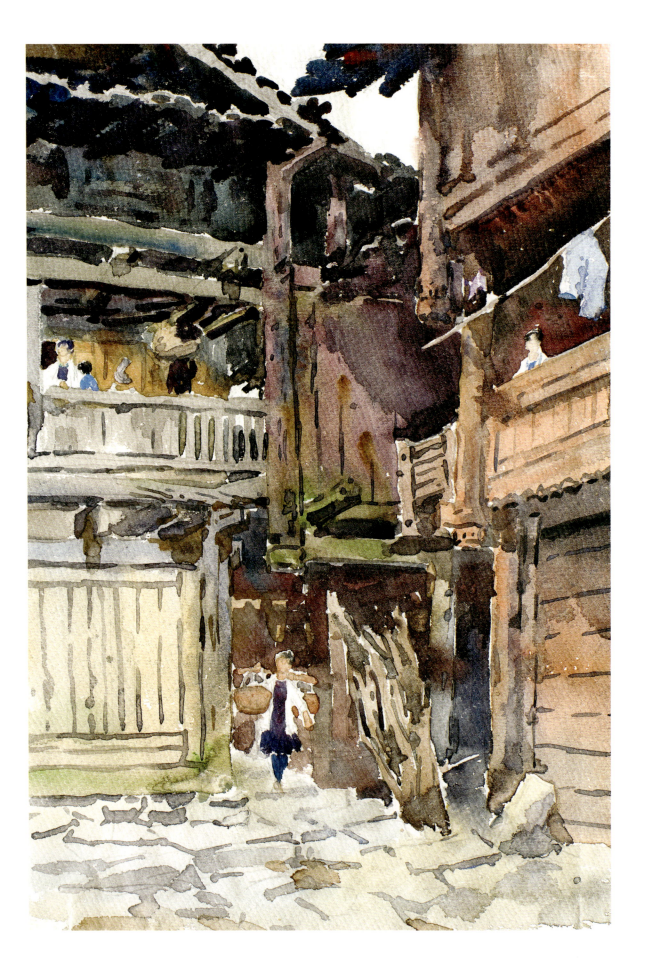

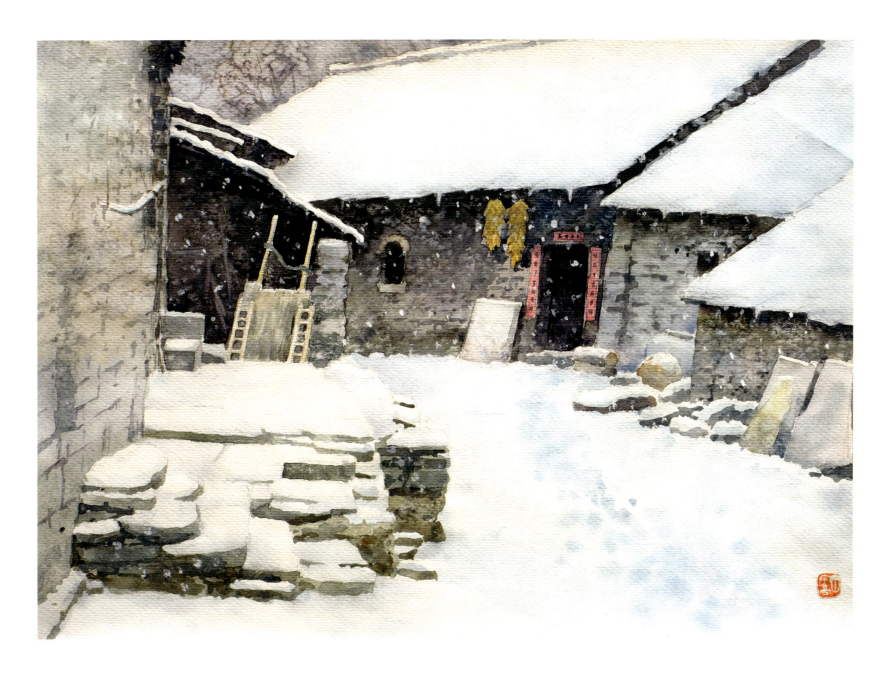

∧ 岁末　53cm×38.1cm　1990年　‖　End of Year　53cm×38.1cm　1990

< 侗寨人家　39cm×26.5cm　1981年　‖　Family of Dong Village　39cm×26.5cm　1981

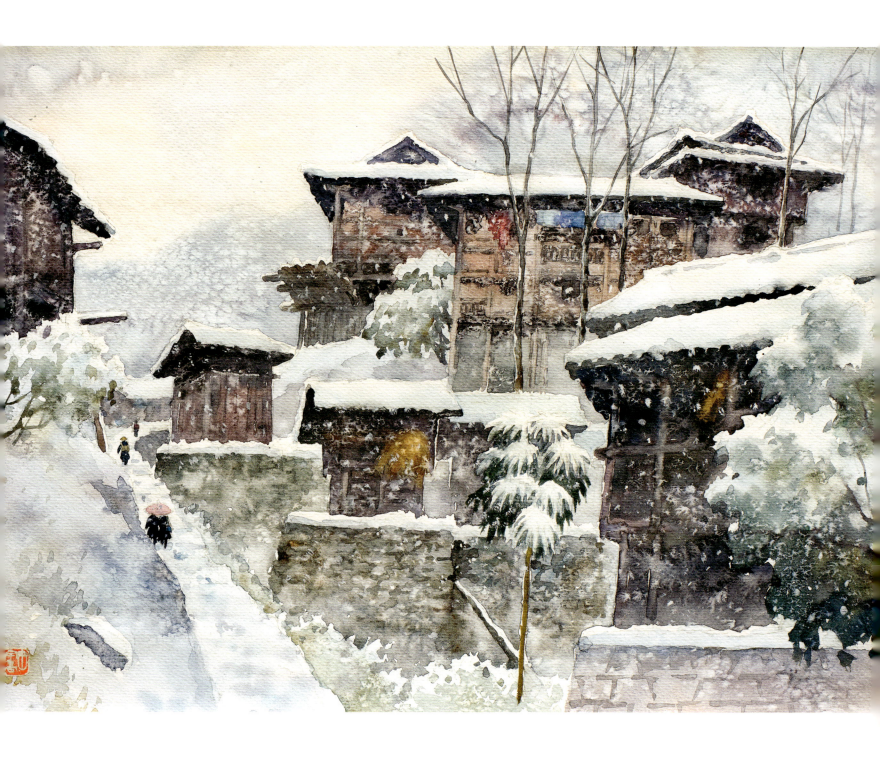

苗寨瑞雪　53cm×38.7cm　1984年　‖　Seasonal Snow in Miao Ethnic Village　53cm×38.7cm　1984

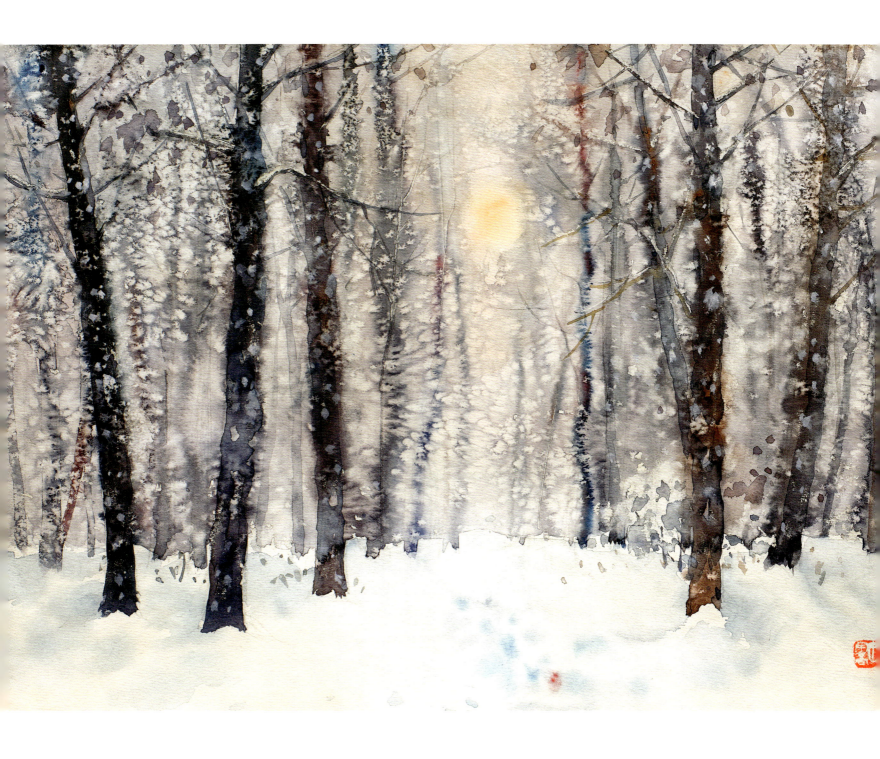

雪林　51.5cm×36.5cm　2002年　‖　Snow Forest　51.5cm×36.5cm　2002

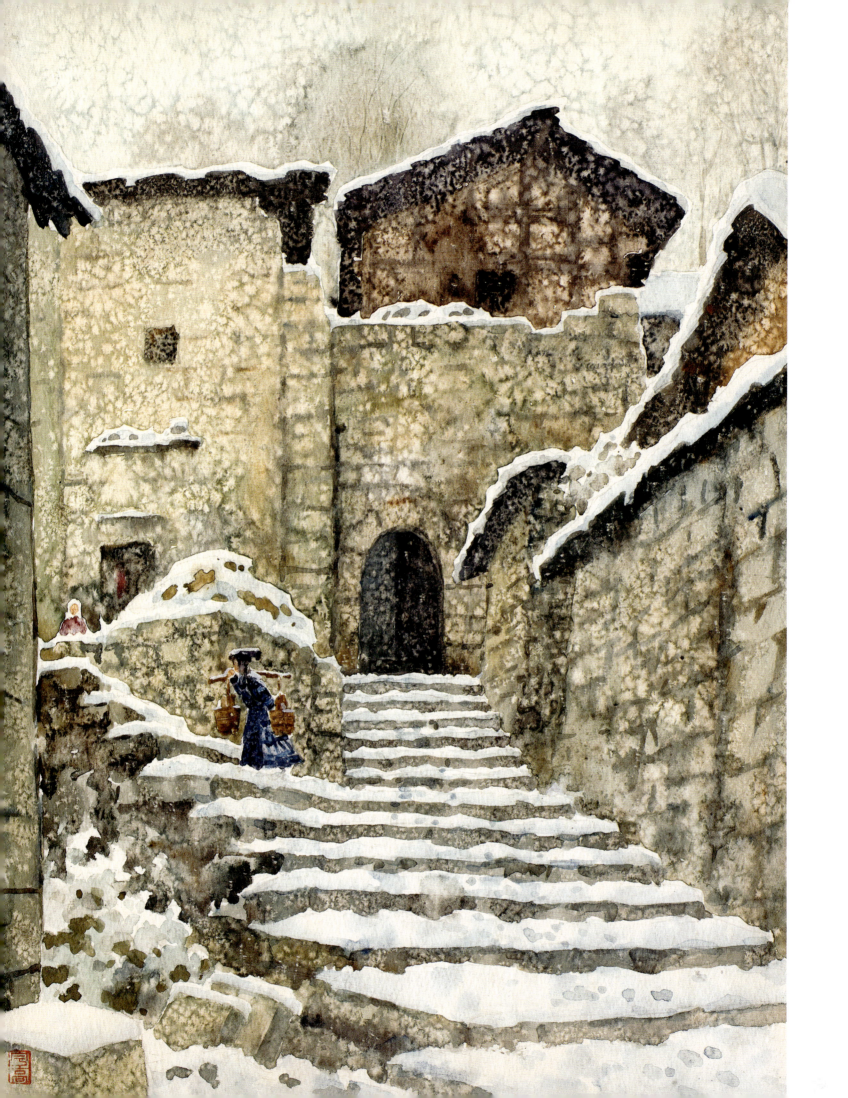

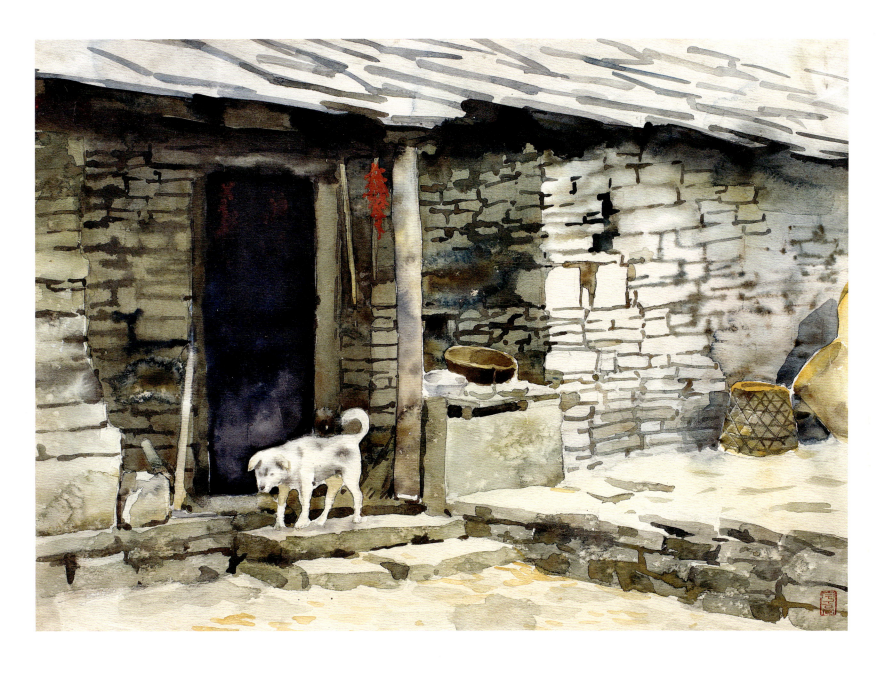

∧ 待　53cm×38cm　1989年　‖　Waiting　53cm×38cm　1989

< 石头寨的冬天　52cm×38.5cm　1986年　‖　Winter of Stone Village　52cm×38.5cm　1986

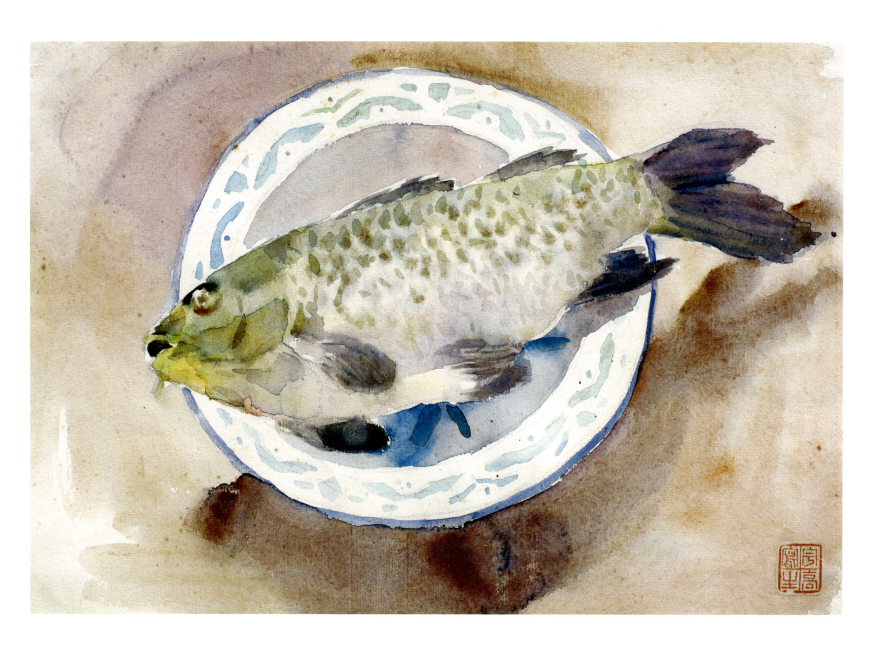

∧ 鱼　38cm×26.3cm　1990年　‖　Fish　38cm×26.3cm　1990

＞ 蟹　49cm×38.2cm　2004年　‖　Crab　49cm×38.2cm　2004

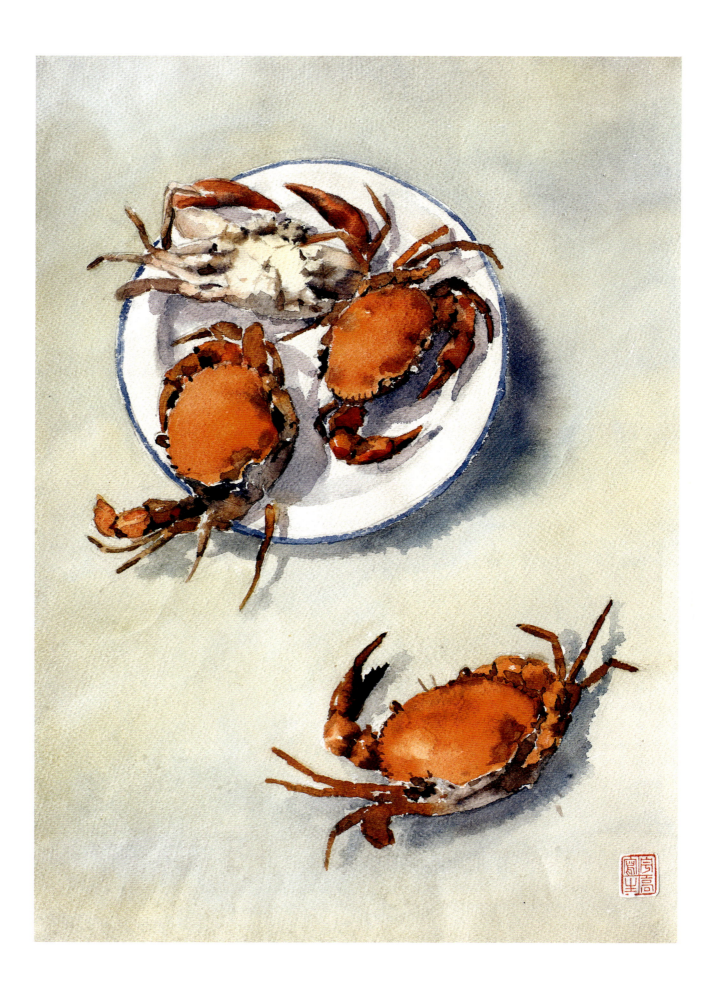

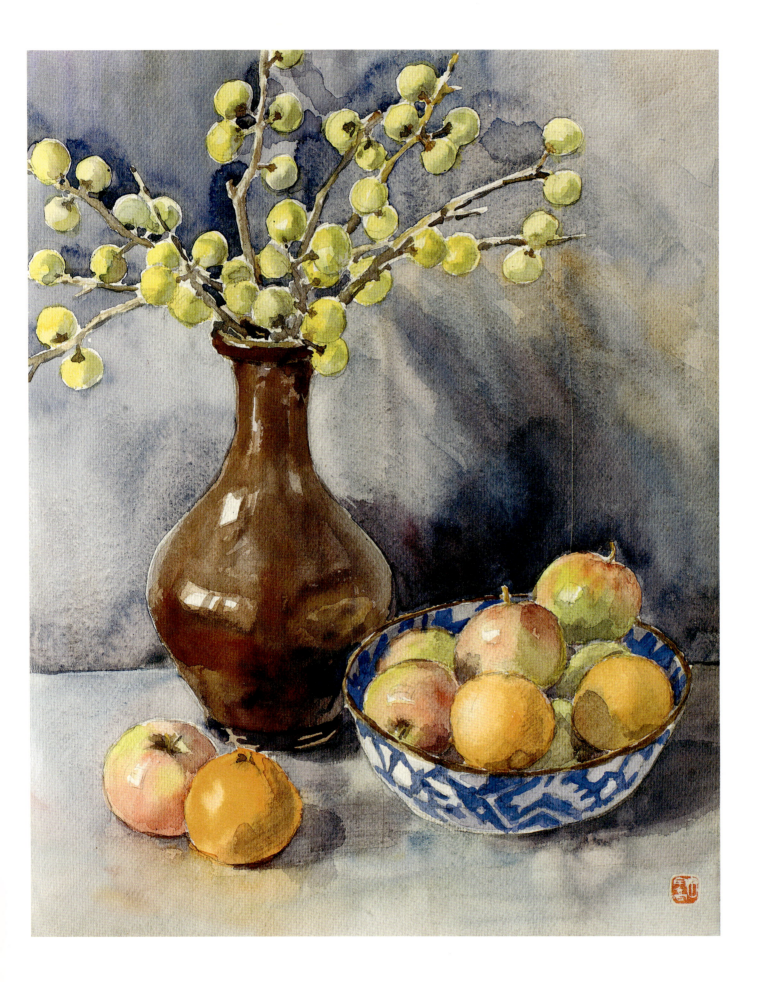

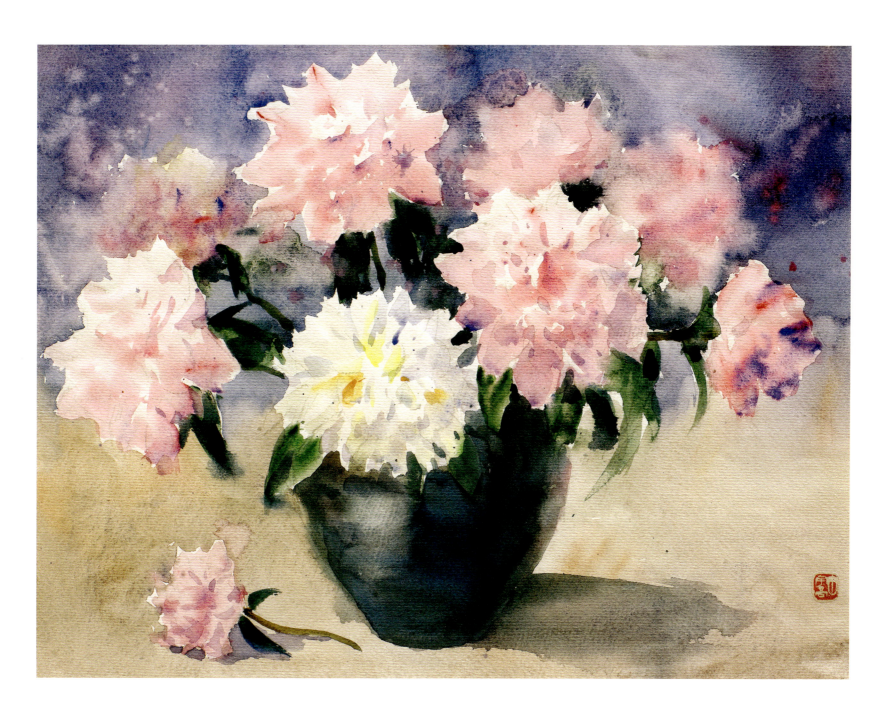

∧ 芍药　49.5cm×38cm　2003年　‖　Chinese Herbaceous Peony　49.5cm×38cm　2003

< 静物　47.4cm×38.1cm　2006年　‖　Still Life　47.4cm×38.1cm　2006

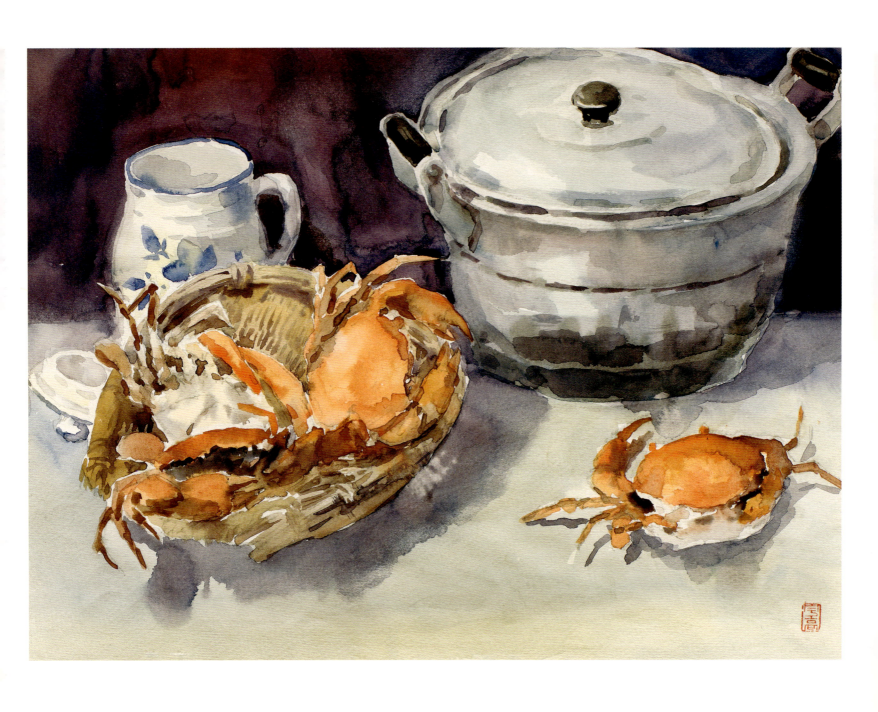

锅和蟹　46.7cm×34.7cm　1995年　‖　Pan and Crab　46.7cm×34.7cm　1995

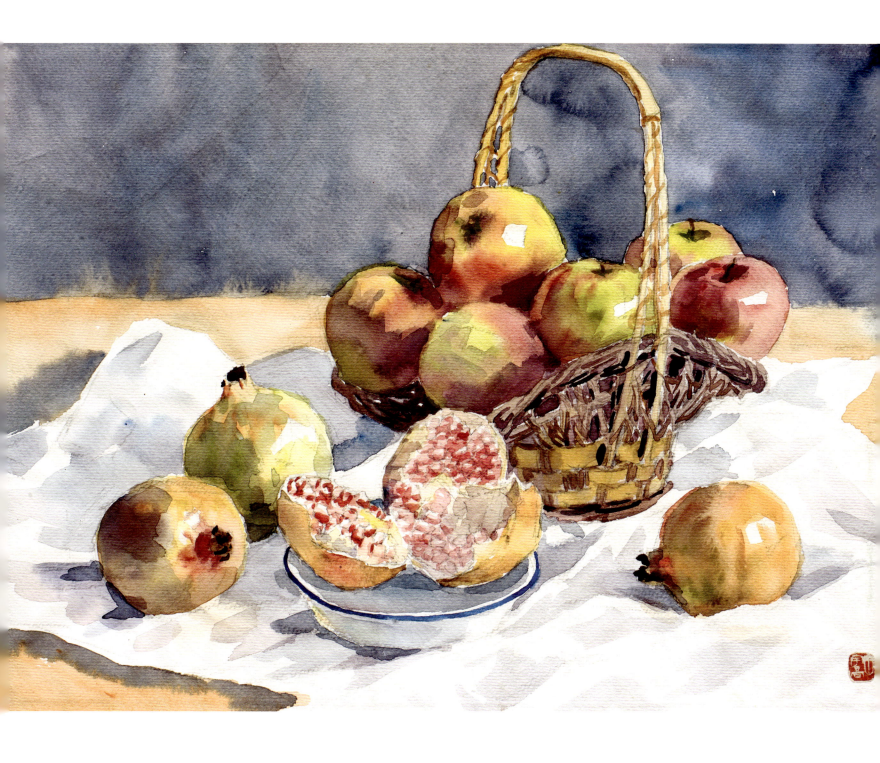

苹果、石榴　53cm×38.5cm　2004年　‖　Apple and Pomegranate　53cm×38.5cm　2004

步骤图
Step by Step

布衣小院
Pretty Courtyard of Buyi

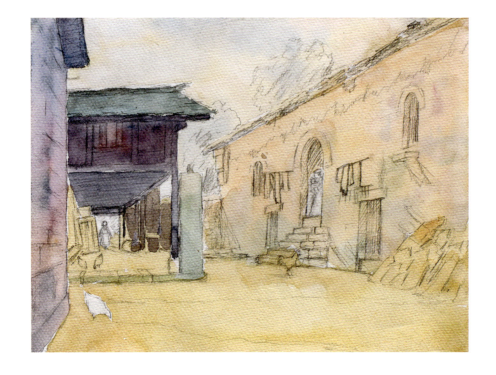

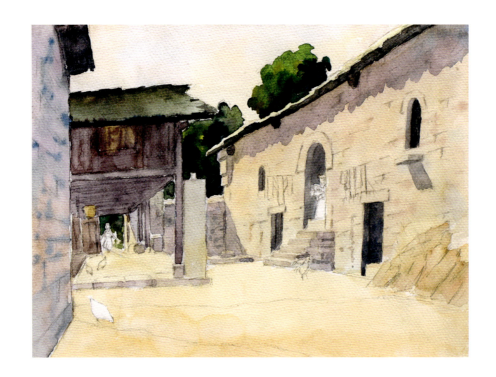

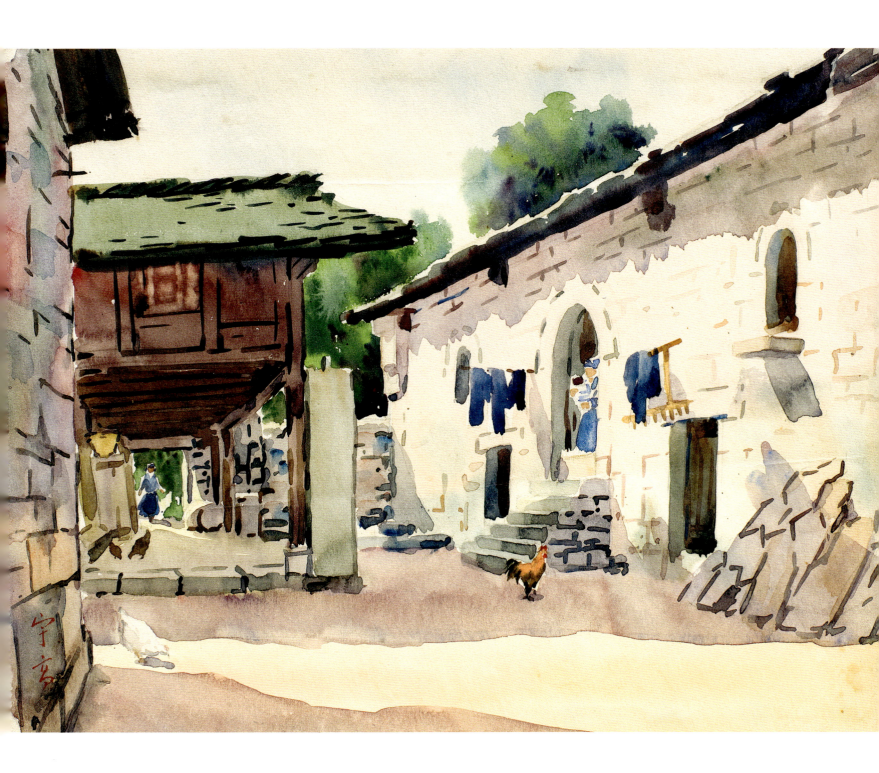

灶台上
On Top of Kitchen Range

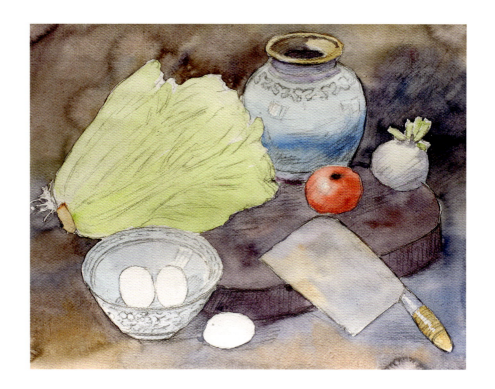

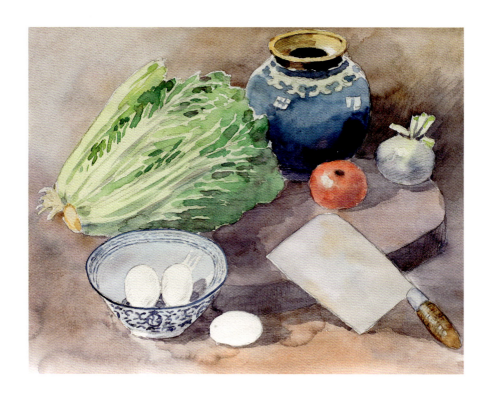

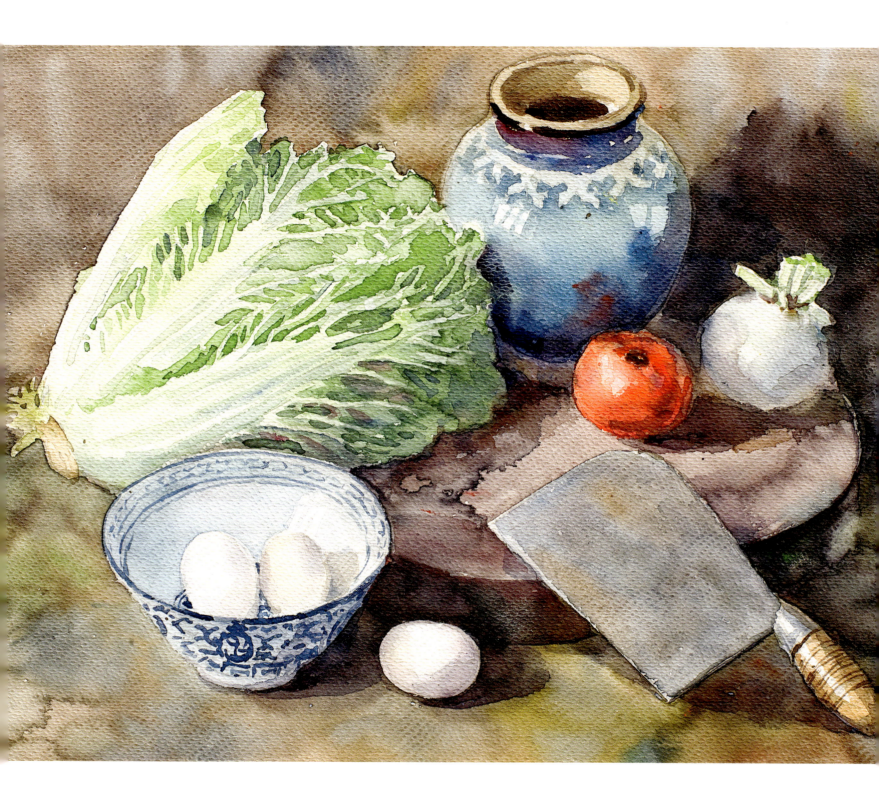